THEN *&* NOW

THE THREE
VILLAGES

Opposite: In Scott's Cove, around 1925, are the remains of two ships abandoned because their repair was no longer profitable as the local shipping industry declined. The remains of the *Deborah Hendrickson* are at the front, and the more recently abandoned *Louise* is behind her.

THEN & NOW

THE THREE VILLAGES

Three Village Historical Society

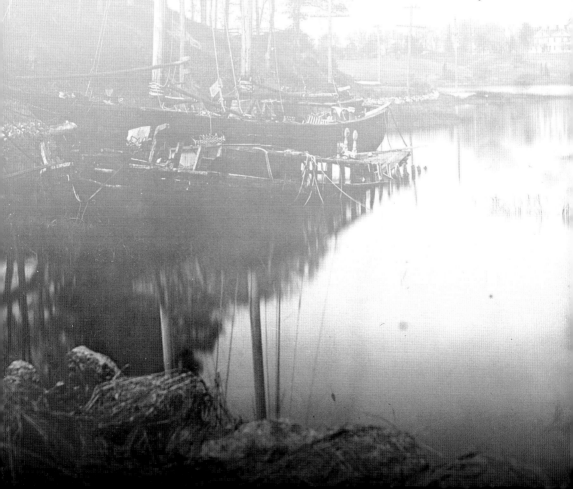

This volume is dedicated to the memory of Kenneth "Lightning" Tuck (1931–2007). Kenneth was a quiet man who made it his mission in life to care for the cemeteries in the Three Village area. He had a sequence for visiting each cemetery and religiously made his rounds in all seasons for more than 10 years. The community will be a little bit less orderly with his passing.

Copyright © 2008 by Three Village Historical Society
ISBN 978-0-7385-5544-7

Library of Congress control number: 2007932713

Published by Arcadia Publishing
Charleston SC, Chicago IL, Portsmouth NH, San Francisco CA

Printed in the United States of America

For all general information contact Arcadia Publishing at:
Telephone 843-853-2070
Fax 843-853-0044
E-mail sales@arcadiapublishing.com
For customer service and orders:
Toll-Free 1-888-313-2665

Visit us on the Internet at www.arcadiapublishing.com

On the front cover: From the 1920s to the early 1940s along Christian Avenue in Stony Brook was a small business district serving the local community. From left to right are the post office, the firehouse, Smith's Market, Henry Peterman and Harold Norton's Village Grocer, O. C. Lempfert Insurance, and Gould's Candy and Stationery Store. (Courtesy of Bee and Susan Jayne.)

On the back cover: The Setauket House was located on Main Street by the Setauket millpond. This general store, owned by the Tyler family, was built around 1870 and stood until around 1930. In the mid-1880s and into the 1890s, it was also the local post office. It was located on the approximate site of the present-day Setauket Post Office. (Courtesy of Beverly and Barbara Tyler.)

CONTENTS

Acknowledgments

Founded in 1964, the Three Village Historical Society is a predominantly volunteer-driven not-for-profit organization whose mission is to educate the public about the rich and venerable history of the Three Village area. The society draws its inspiration from the distinctive and diverse community it serves and its strength from the time and talents of a group of over 300 volunteers. This nationally recognized, award-winning historical society offers both in-school and off-site history-based programming to Long Island's students in grades kindergarten through 12 as well as to the general public. In addition, the society publishes a quarterly newsletter, creates exhibitions, compiles extensive stores of research, sustains a hearty oral history program, adds documents and ephemera to its wide-ranging collection, works to compile engaging and inspiring publications, and boasts a robust membership base of over 700 individuals.

Countless individuals and groups have contributed to the development of this book. Firstly, the society wishes to thank the staff and board of trustees of the Emma S. Clark Memorial Library, which graciously houses the society's archives, known as the Captain Edward R. Rhodes Memorial Collection of Local History, and provides support to those who use the collection for research.

Additionally the society extends a heart-felt thanks to the many Three Village residents and their families, near and far, who have shared photographs, diaries, memoirs, and documents. Without their generosity, the society's understanding of the region would be wholly limited. A considerable debt of gratitude is also owed to Sy Robbins, whose comprehensive project of tracing and computerizing local deed histories and wills has provided much of the historical basis for the text.

Lastly the society wishes to thank the true authors of this book: Harold "Hap" Barnes, Barbara Brundage, Gene "Sticky" Cockshutt, Carleton "Hub" and Nellie Edwards, Pete Fraccalvieri, the late Robert "Buddy" Gerard, Bee Jayne, Susan B. Jayne, Billy Leonard, Ken and Bob "Boo" McCambridge, Charlie Post, the late Ken "Lightning" Tuck, and Betty Voss. This publication would not have been possible without their contributions of pictures and documents, their keen memories, and their dedication to the society's oral history group, and the Rhodes Committee.

Unless otherwise specified, all photographs are the property of the Three Village Historical Society. Furthermore, the tireless efforts of Susan Jayne should be recognized. Susan is responsible for all the contemporary photographs, all of which date from 2007. Susan's effort to find the right angle, time of day, and time of year to match the early photographs was nothing short of remarkable.

—Frank Turano, Elizabeth (Betty) Voss, Beatrice (Bee) Jayne, Karen Martin, and Sarah Abruzzi.

INTRODUCTION

In 1929, the term Three Village was adopted by the local garden club. The name was then applied to the Three Village Teahouse and Women's Exchange in 1931 located in what is now the Three Village Inn. The term was then applied to the north shore school district that covers the area from the Smithtown line to Port Jefferson. The principal areas of Three Village are Setauket, East Setauket, and Stony Brook but it also includes the incorporated villages of Old Field and Poquott and the area to the south formerly known as Nassakeag. The senior village, Setauket, was originally founded in 1655 as the town of Ashford, renamed Brookhaven, and finally Setauket. It was the first settlement in what is now the town of Brookhaven.

By the early 18th century, a road, now Route 25A, wandered along the north shore of Long Island with occasional ordinaries, taverns/inns, to accommodate travelers scattered among and between villages. Steamers from New York had alerted the city populace to the countryside to the east and to the summer sojourns awaiting those who could afford them. The arrival of the Long Island Railroad in the 1870s further opened the area to summer visitors and boarding houses sprung up near the shore. These boarding houses and the summer homes that followed provided the middle class and wealthy families with a summer haven from the perils of the city. Supporting these summer people were the local families of farmers, shopkeepers, baymen, and laborers. As time passed, some of these summer folk took up year-round residence at their former summer homes. Just prior to World War II, one of these former summer people began projects throughout the Three Village area that would transform much of the area. Many buildings were moved from their original locations and adapted to new uses and a new village was constructed at Stony Brook.

Frank Melville Jr., a prosperous New York businessman, and his wife Jennie, had come to the Three Village area as summer visitors just before the dawn of the 20th century. They soon took an active part in village life and in the removal, movement, and replacement of older buildings. In the 1930s their son Ward and his wife, Dorothy, joined the senior Melvilles in their work, which was made all the more compelling by the local effects of the depression.

As the age of automobile travel engulfed Long Island, the Smithtown business district became a bottleneck on Sunday afternoons. In the late 1950s, the construction of the Smithtown By-pass, Route 347, alleviated this problem and the area of Stony Brook, Setauket, and Port Jefferson became more accessible. In the 1960s, this precipitated the conversion of many farms, south of the old business districts, into housing developments and provides the landscape that we see today.

Ward Melville's donation of land to the State of New York for the establishment of a small teachers college was a further major step in putting Stony Brook on the map. The

small teachers college moved from its temporary quarters in Oyster Bay in 1965, and quickly became one of the major university centers for the state of New York. With this expanded role came the demand for housing for faculty, staff, and students that has spurred the current development of the area. This new population put in place the demand for quality schools and amenities that continues to this day. It also brought a racial, ethnic and cultural diversity to the community that had never existed in the past.

The map of Long Island is peppered with Native American place names. Many contemporary residents take these names for granted and do not recognize their origin. Over the generations of inhabitants, names have been added or changed to commemorate an event, a person, or to modernize. In many cases the original names are forgotten or used in a different context. For a period of time, Setauket was known as Ashford, Stony Brook as Wopowog, and South Setauket as Nassakeag. Only the name Nassakeag survives as the name of an elementary school. The name West Setauket is no longer used and barely remembered.

The hamlet of Norwood was about two miles south of East Setauket and is now only a street name. A list of names the thoughtful reader may question could include: Crane Neck, Conscience Bay, Ridgway (no "e"), Lubber Street, Cat Hollow, Aunt Amy's Creek, and Flax Pond. Any number of streets were named after people. Who were the Erlands, the Terrells, or the Bennetts, to name a few? Careful reading of the following pages will reveal the location of Native American ground, as well as locations for Cardwell's, Pfeiffer's, Wood's, and Mungeer's corners. Always the question is the same: Why this particular name? Enjoy the search.

Finally, although we have made every effort to avoid errors, we expect to receive challenges and corrections to what we have written. We are grateful for any information that will improve the accuracy and scope of future editions.

—Frank Turano

CHAPTER 1

SETAUKET HARBOR AND ITS ENVIRONS

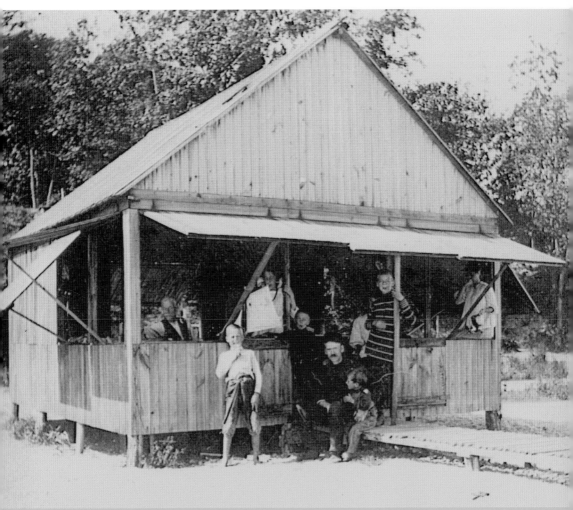

Shown here is the Brundage family kitchen cottage on the Poquott Beach at Port Jefferson Harbor in 1906. (Courtesy of Barbara Brundage.)

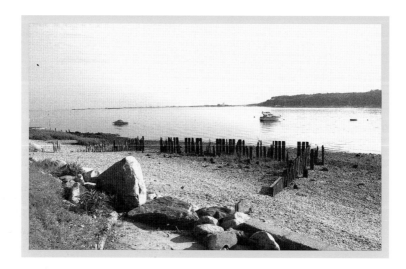

Today all that remains of the old oyster dock at the Poquott Village Beach is some weathered pilings. Located at the foot of Washington Avenue, it was a successful shellfish business operated by Henry Schmeelk from approximately 1905 until 1934. This area in the 1880s was known as California Grove, a popular picnic area and amusement park, which attracted guests from New York City arriving by steamboat. (Courtesy of Barbara Brundage.)

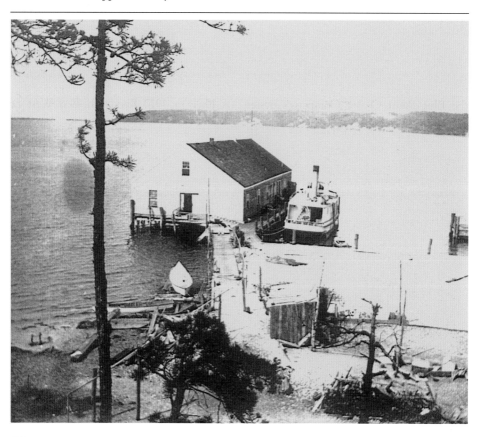

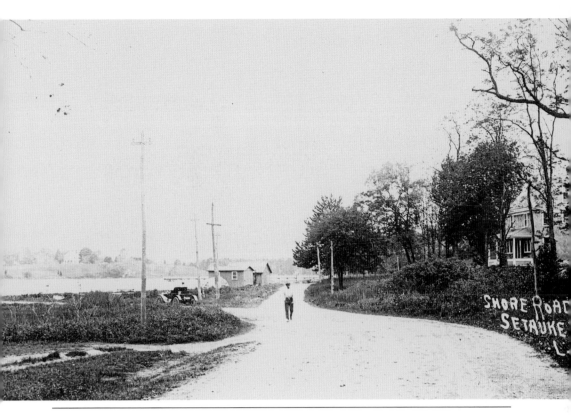

Van Brunt Manor Road meets Shore Road at Scott's Cove. The two small buildings at the center of this c. 1911 photograph are the Blue Point Oyster Company's oyster houses. Although the oyster houses are gone, the James Arthur Van Brunt home, built in 1911, continues to overlook Scott's Cove today. The car at the intersection is likely a 1910 Reo with Ben West at the wheel.

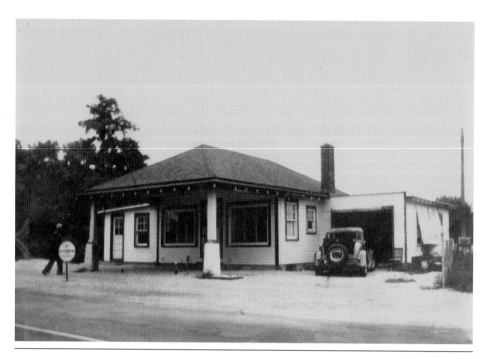

Approaching East Setauket from Port Jefferson along Route 25A is Cooper's Service Station, built around 1920. It served the community until it was purchased by Joseph Arnaboldi, D.V.M., who converted the station to his veterinary hospital around 1950. Today this practice is operated by Dale Kuhn, D.V.M., who provided this vintage photograph.

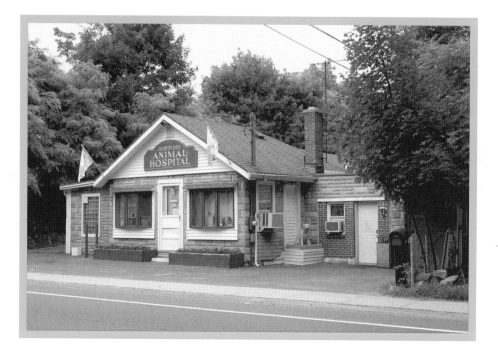

Croxton "Crocky" Cardwell established this service station in East Setauket on January 6, 1927, on the south side of Route 25A at Van Brunt Manor Road. He sold Mobil gasoline, kerosene, and ice cream. Cardwell, a longtime Setauket fire chief, was known to abandon his customers in mid-service to respond to an alarm. The station operated until Cardwell's death in 1976. This stretch of road from Port Jefferson was known locally as "Suicide Bend." Recently a private home was built on the site. (Courtesy of Charlie Post.)

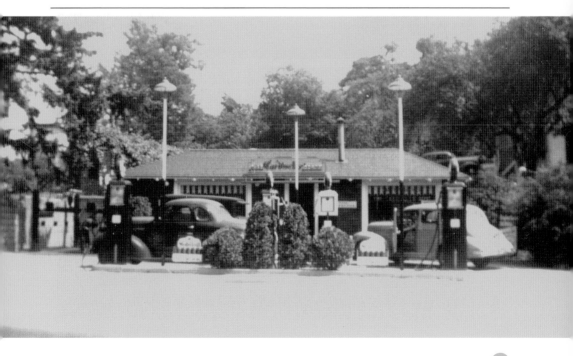

Shortly before the American Revolution, Austin Roe converted this *c.* 1703 private home into a tavern. The Setauket or Culper Spy Ring centered its operations here during the Revolution. In 1790, during his tour of Long Island, Pres. George Washington stayed at the tavern. Located at Bayview Avenue, the former tavern was moved in 1936 when New York State widened Route 25A. The owner, novelist Wallace Irwin, moved it to a parcel off Old Post Road. Today a modern home occupies this historic site.

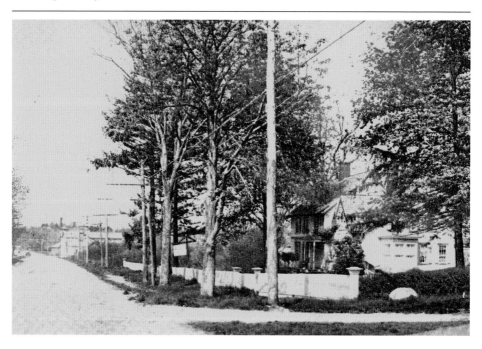

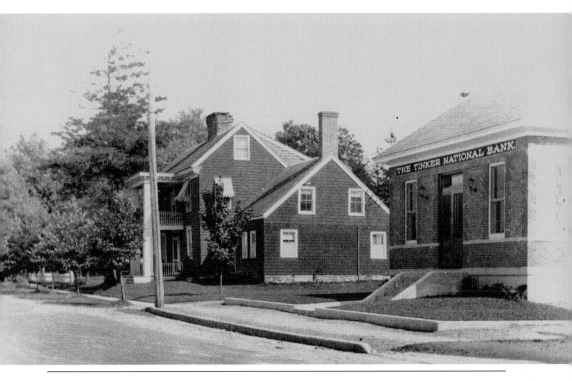

On opening day, August 28, 1920, the Tinker National Bank took in $135,000 in deposits. Founder and local businessman Edward L. Tinker constructed this building on the south side of Route 25A opposite Shore Road. Today this is a branch of HSBC. Old Shinglesides (left) in the c. 1940 image was moved to Mills Lane in 1962. The following June, the East Setauket Post Office was dedicated on its site. The post office relocated in 1979, and this building has since been occupied by numerous restaurants.

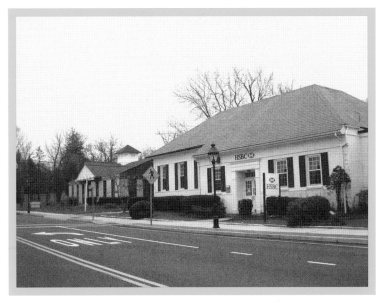

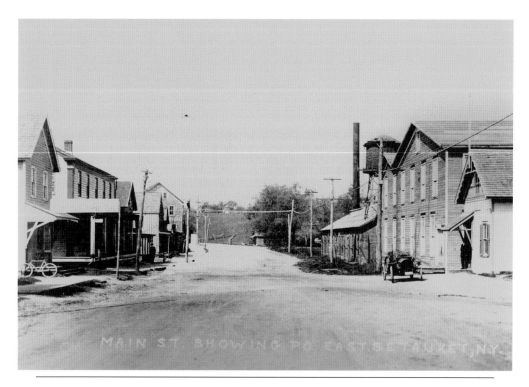

Along Route 25A, around 1910, the small East Setauket Post Office (right) is located just west of Shore Road. The lower rubber factory buildings to its left produced second-quality boots and shoes. These factory buildings were removed by 1940, and the area is now East Setauket Pond Park. Across the street was the store of Brewster and Bayles, which sold coal, gasoline, and oil. The long two-story building next door eventually became Steve Bossey's general store. These two buildings have been replaced by the HSBC parking lot.

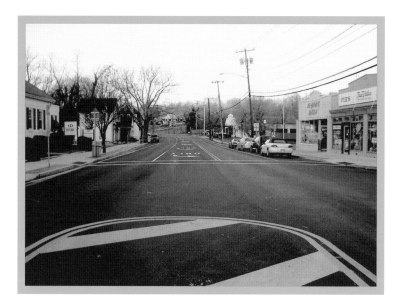

SETAUKET HARBOR AND ITS ENVIRONS

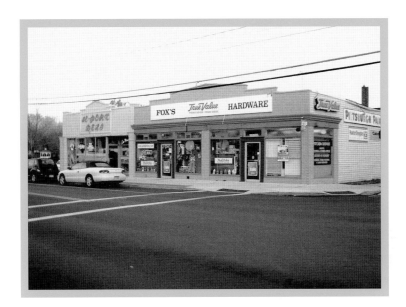

In this c. 1930 photograph, Mather's Drug Shop and Lyon Brothers Contracting Company occupy the present site of Fox's Hardware on the corner of Shore Road and Route 25A. The Se-Port Deli now occupies the Great Atlantic and Pacific Tea Company building constructed around 1930 on the site of the old post office seen on the facing page. In the 1920s, the post office was moved to its present site facing Shore Road.

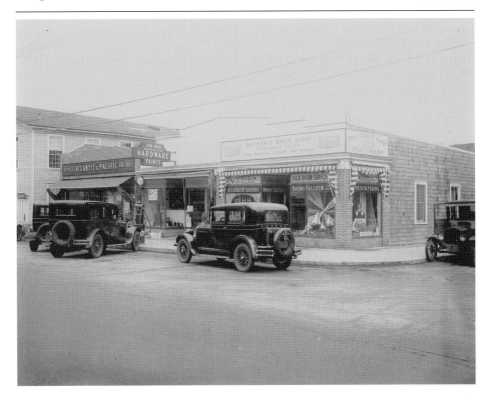

This annual fire department festival and block party, shown here around 1924, took place along Shore Road. This booth next to the old Setauket Firehouse was decorated for the occasion. The small building farther down the road served as a Boy Scout meetinghouse until 1929, when the Scouts moved to their new building on Jones Street. Today these three buildings are gone and the former Lyon Boat Yard building from 1929 occupies the site. (Courtesy of Ed Meachum.)

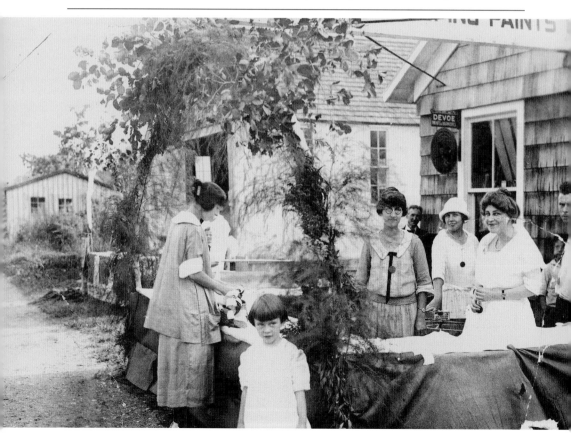

SETAUKET HARBOR AND ITS ENVIRONS

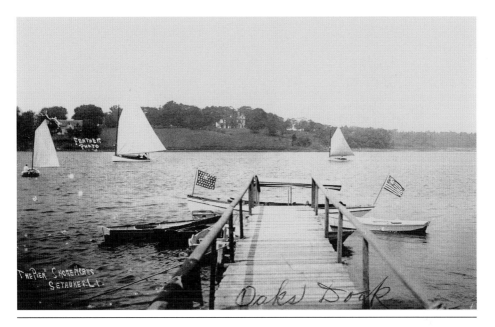

After the decline of the shipbuilding industry in East Setauket, boardinghouses developed and mixed with private residences along Shore Road. Oakes' Dock, pictured in this 1910 photograph, served Shore Acres, operated by William Decatur Oakes, where summer guests would enjoy swimming and boating in Setauket Harbor. The boardinghouse was razed in 1962. The dock has long since disappeared. A Strong family home, St. George's Manor, can be seen across the bay on Strong's Neck. (Courtesy of Marilyn Wishart Varga.)

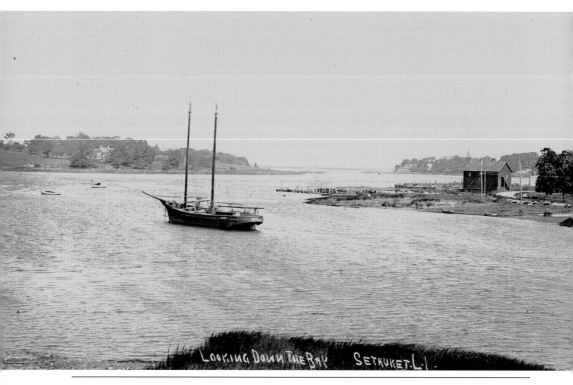

Looking Down The Bay Setauket L.I.

This *c.* 1910 photograph was taken looking northeast across Setauket Harbor. The two-masted schooner, possibly the *Louise* sailed by Capt. Alfred Nelson from Port Jefferson, is anchored at the center. These ships tended to operate in the cordwood trade. The building at the right on the turn of Shore Road is the old ship chandlery. In 1877, George Hand constructed this woodworking shop for his shipyard on Shore Road. Today these graceful ships have been replaced by a variety of pleasure craft.

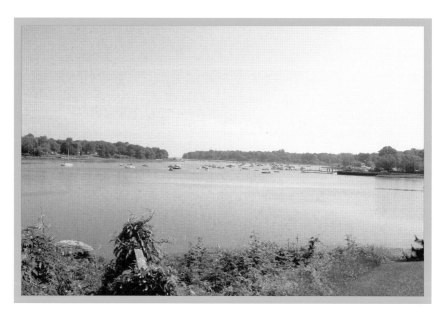

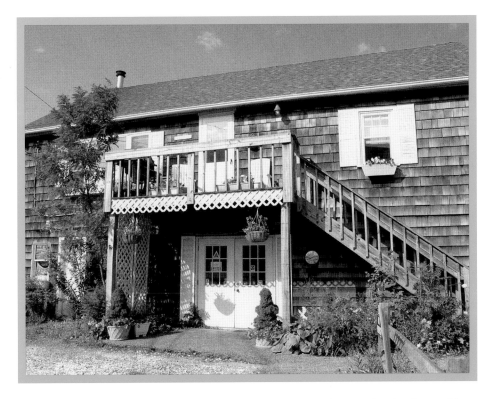

In the 1930s, when John Hitschler decided to relocate his Jamaica Bay Boat Livery to Setauket, he towed all his rental boats through New York Harbor and out to Setauket using his 45-horsepower motorboat *Old Pal*. Here John (fourth from right) took over the former ship chandlery on Shore Road. His wife, Mae (second from right), served meals in the "one choice" lunchroom in this 1940 photograph. Today this is Setauket Harbor Marina. (Courtesy of Mike and Jeanne Compitello and Stuart Fitz.)

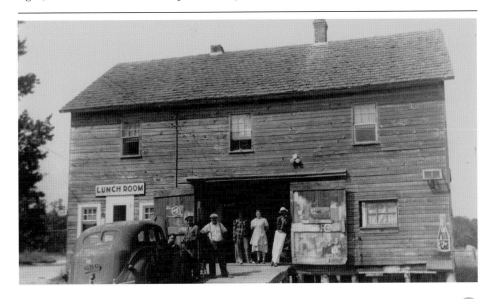

Shown in 1954, Steve Bossey operated a general store at this location, on the south side of Route 25A, from 1946 to 1958. After he closed, Richard and Gloria "Bunny" Woreth operated a furniture store here. Don Hathaway was the baker next door.

This building was constructed in the late 19th century and had operated as a tavern or store throughout its history. In 1970, after merging with Tinker Bank, Marine Midland Bank bought the property and demolished it for a parking lot.

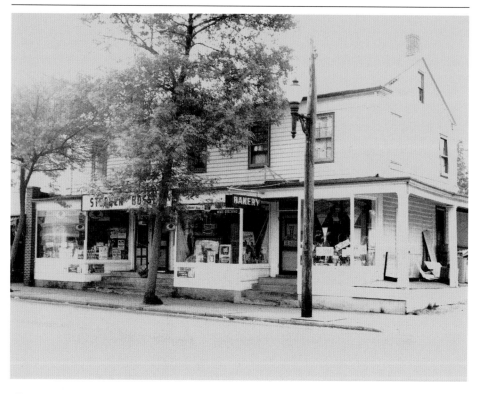

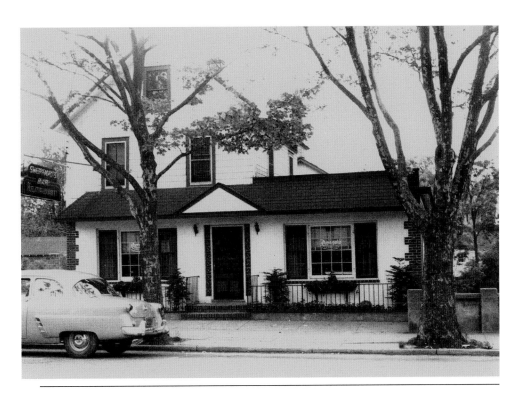

This building on the south side of Route 25A is best known as Sheppard's Bar and Grill, previously Charlie Jayne's Confectionery, selling candy, tobacco, and cigars. Jayne's was the center of a continuous poker game that extended to the days of Sheppard's Bar. Sidney Sheppard sponsored the local Setauket baseball team, and the bar provided a home base for the team. By the time of this 1954 photograph, Sheppard's was owned by Joe Bolduc, a Canadian. Today a women's boutique occupies the building.

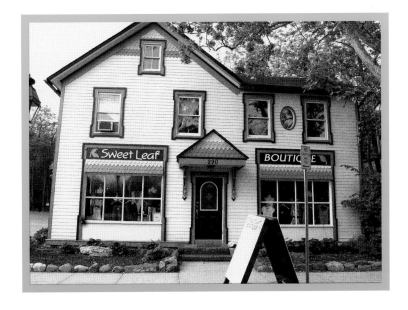

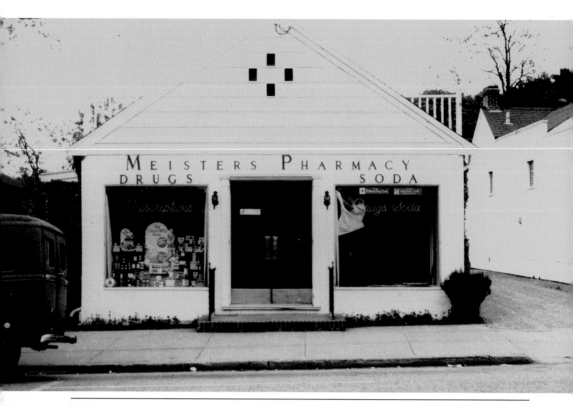

In the mid-1940s, Edward Meister moved his pharmacy and soda fountain from the corner of Shore Road across Route 25A to this larger building. The right side was devoted to glass cases filled with cosmetics with the pharmacy at the back. The soda fountain was on the left. Behind it was the "snuggery," a group of small booths popular with couples. Oliver Kemble, Brookhaven town assessor, hung out here and continually talked baseball and was known as "the Turtle" for his speed.

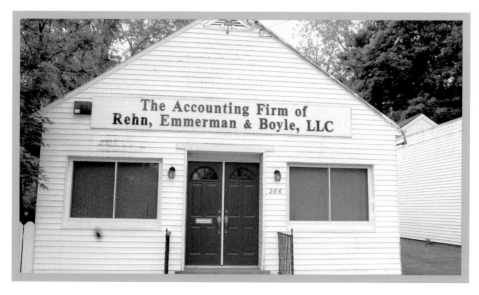

This 1954 photograph shows Robert and Blanche Eikov's butcher shop, on the south side of Route 25A. After their marriage, Robert and Blanche constructed this building and lived in an apartment at the rear of the store. Their building replaced Charlie Peters Feed and Grain.

The butcher shop was an old-fashioned, cut-to-order shop with sawdust on the floor. Later Robert gave up the butcher shop and turned it into a liquor store. The building continues to operate as a liquor store today.

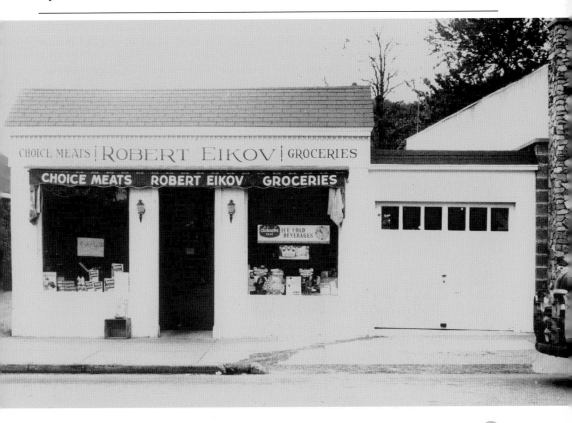

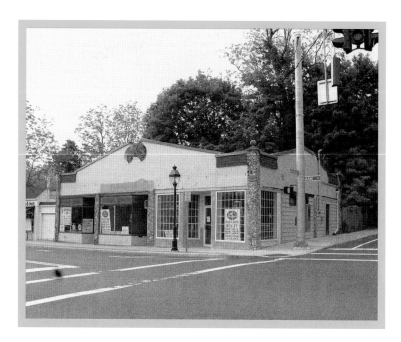

In 1926, E. M. LaRoche built this series of stores (shown in 1954) extending east from Gnarled Hollow Road along Route 25A. From right to left are Moffetts Department Store, the East Setauket Post Office, and Oscar M. Lindquist's Tailor Shop. Behind Moffett's is the home of Sara (Sarry Ann) Sells. She was a Native American who welcomed anyone into her home and had the respect of the community. Sells's house has been removed, and a variety of businesses have occupied these stores over the years.

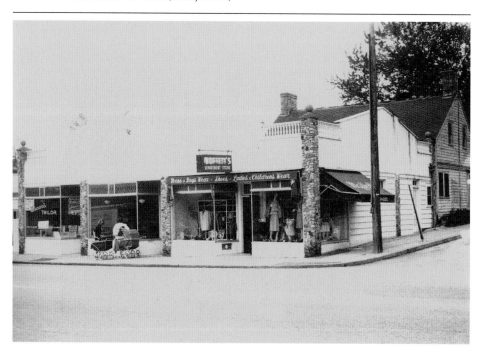

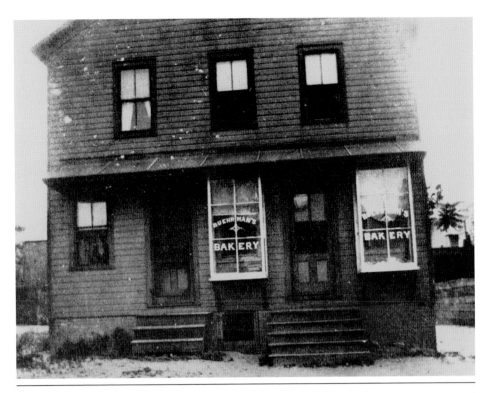

Buehrman's Bakery, shown in this *c.* 1900 photograph, was located on the southwest corner of Gnarled Hollow Road and Route 25A, behind the Country Corner Tavern. As with many business of the time, the family lived on the second floor. This was also the home of Ray and Lena Buehrman Tyler. Ray was a painter, photographer, and artist. He specialized in painting steeples and flagpoles, taking the opportunity to photograph from these heights. The store is now a private home. (Courtesy of Betty Voss.)

McDowell's grocery store on the southwest corner of Route 25A and Gnarled Hollow Road is pictured here around 1910. Jim McDowell turned this into a bar and grill, with a dance hall upstairs and later a retail store selling radios. In 1950, Jack Michaels purchased the property and returned it to a bar. From left to right are Charlie Sharp, Jim McDowell, and Pat McDowell (Jim's father). (Courtesy of Betty Voss.)

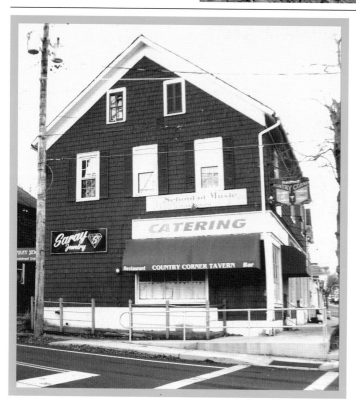

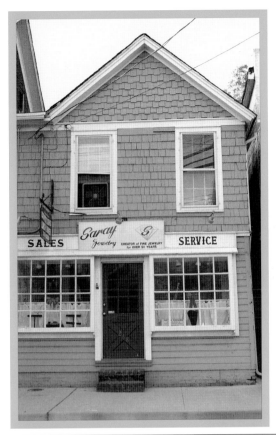

In this 1954 photograph, the western extension of Country Corner is occupied by Bradford Photographic Studio. For a short time, this was also the location of a gun shop and most recently a jewelry store. Within this block many of the early storefront buildings still exist today, but with changes to their facades.

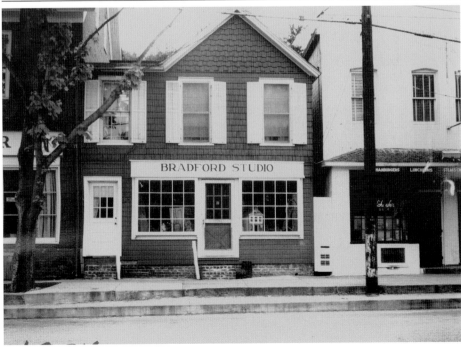

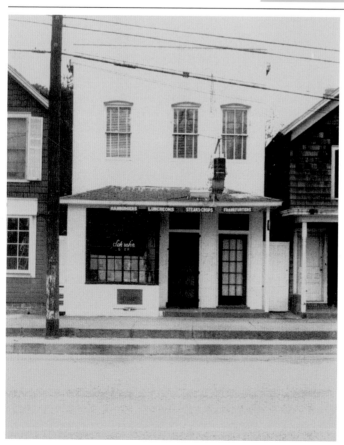

This saloon, owned by Mary and Carl Mueller between 1945 and 1956, was known locally as the Cave and Dirty Mary's. The Muellers lived above the bar, which featured a shuffleboard game and pinball machines. The bar was also frequented by the local baseball team. Shown in 1954, it is presently an art gallery and sits on the south side of Route 25A.

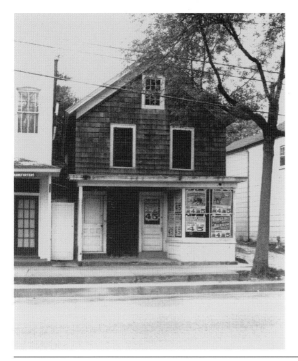

Filippo Lanieri's shoe repair shop occupied this building from 1923 to 1954. Ringling Brothers and Barnum and Bailey Circus posters covered the windows of the recently closed shoe shop on the south side of Route 25A in 1954. Recently a vacuum repair shop occupied the building.

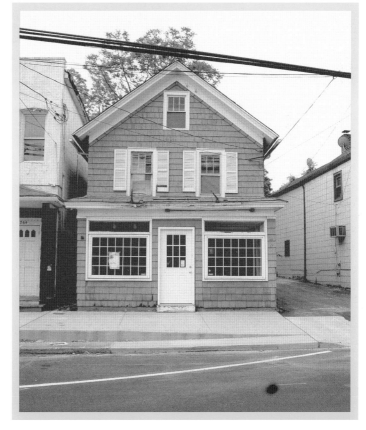

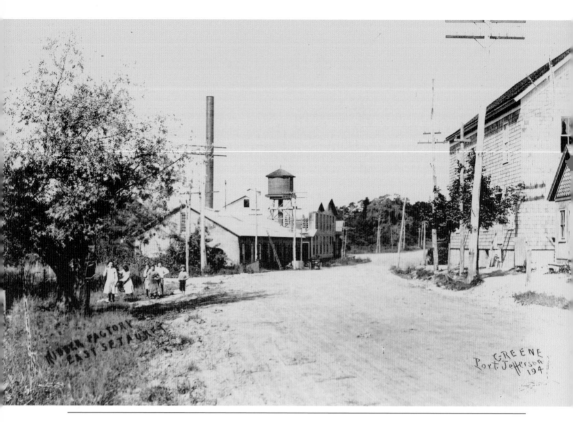

In this 1904 view to the east, Route 25A is a dirt road. The children are standing where Carl Ruland built his garage, which still exists today. The lower rubber factory buildings on the left are now gone. McDowell's building (Country Corner Tavern) remains a constant landmark on the corner of Gnarled Hollow Road, which has in the past been called South Street, Depot Avenue, or Station Road.

SETAUKET HARBOR AND ITS ENVIRONS

Ruhland's Garage is at the left in this c. 1930 photograph of Route 25A. The lower rubber factory buildings are beyond it; the brick building was on the site of the present East Setauket Pond Park. The two-story frame building beyond the water tower was also part of the rubber factory. On the corner of Gnarled Hollow Road (right) is Roulston's Grocery Store. Roulston's was part of a chain of cooperative grocery stores existing in small villages. (Courtesy of Beverly and Barbara Tyler.)

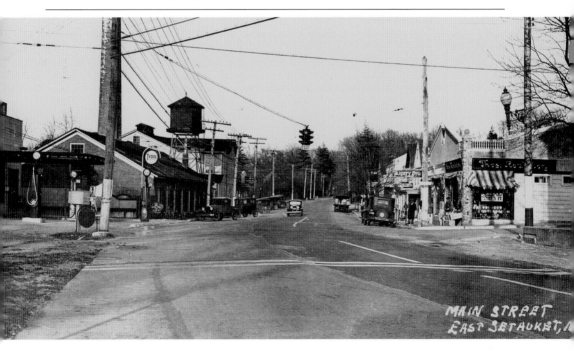

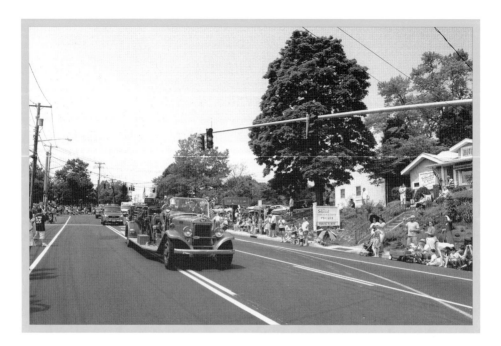

The 1954 Memorial Day parade followed the traditional route along Main Street and Route 25A, from the Setauket Village Green to the Memorial Park in East Setauket. The Cub Scout 117 Troop of Stony Brook is followed by the 1932 and 1952 Mack fire trucks from the Stony Brook Fire Department. The same 1932 Mack fire truck appeared in the 2007 Memorial Day parade above. The view of the Setauket Methodist Church is now obscured by trees. (Courtesy of Bee and Susan Jayne.)

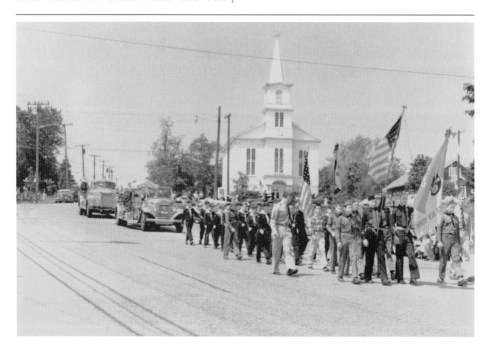

Known as Mungeer's Corner, the sign at left in front of Henry J. Mungeer's real estate office directs travelers to the "Historical Indian Ground," another name for Strong's Neck. The building on the opposite corner of Old Town Road and Route 25A was Hymie Golden's General Store from 1931 to about 1952. The firehouse location on the hill was critical because the path to any fire was down hill to roll-start the fire truck. The Setauket Union Free School, on the hill, is just visible behind the firehouse.

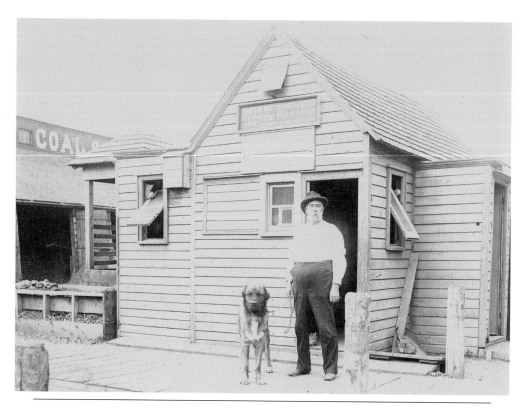

Samuel Smith owned a coal yard just north of the Setauket railroad station on Gnarled Hollow Road. This station of the Long Island Railroad served local commuters until 1960, when it was closed and taken down. The coal yard existed into the 1950s. Today all evidence of the yard is gone and a new building, now Setauket Animal Hospital, occupies the property. (Courtesy of Betty Voss.)

AROUND THE OLDEST VILLAGE IN BROOKHAVEN

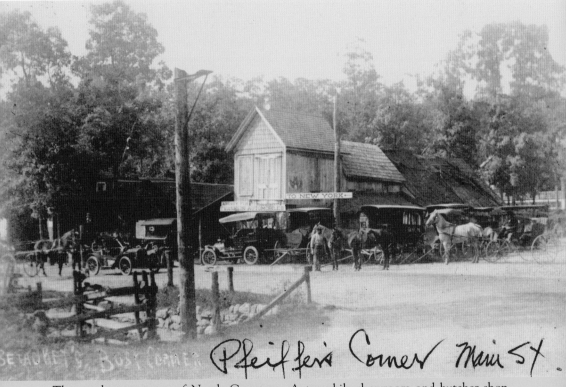

The southwest corner of North Country Road and Ridgway Avenue was known as "Setauket's Busy Corner" or "Pfeiffer's Corner" because of Adolph Pfeiffer's sprawling commercial operations. On this site around 1910, he maintained a Franklin Automobile showroom and butcher shop. Today the only remaining structure from this c. 1910 photograph is the c. 1750 Griffin House among the trees at the right. (Courtesy of Marilyn Wishart Varga.)

The "best burgers around" were at Guy Castro's We Likit stand at August Avenue and Route 25A. It stood where the North Fork Bank parking lot is now from the late 1950s until the mid-1960s, when it was destroyed when a car crashed into it. Nellie Castro is pictured here, around 1955, working the counter in the family business. When the Setauket School on Highland Avenue was demolished, around 1951, its annex was moved here to the northeast corner of August Avenue. (Courtesy of Carlton Edwards.)

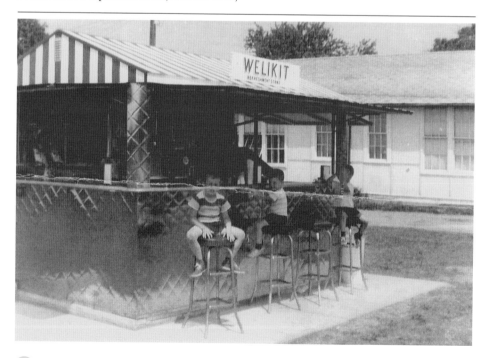

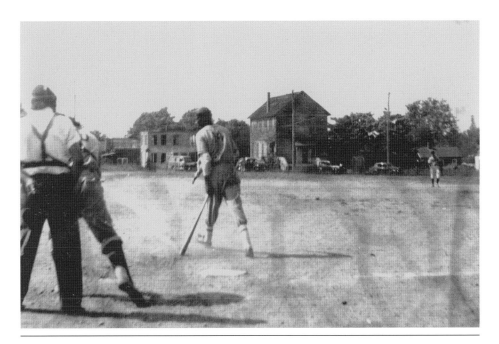

The Suffolk Giants Juniors are playing the Setauket A. C. in this early-1950s photograph taken from the Chicken Hill baseball field looking north toward 25A. The large building in left center field was the old Setauket Village Green School. It was moved to the northeast corner of August Avenue after the Setauket Union Free School was built. It was used as a social hall and for movies until 1951, when it was replaced by the Setauket School Annex (see page 40). The baseball field is now a variety of commercial enterprises. (Courtesy of Everett Hart.)

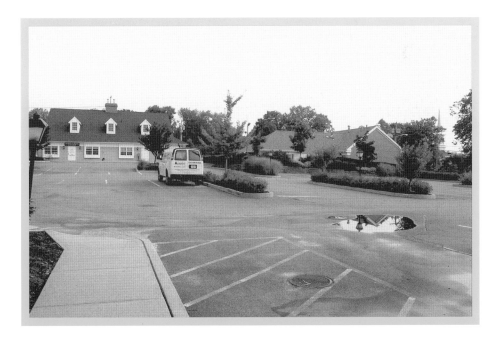

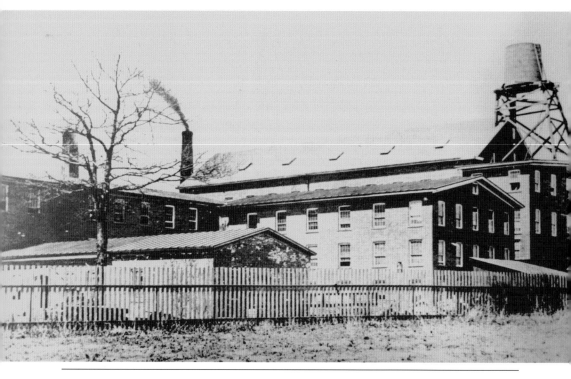

The upper rubber factory complex, along Route 25A east of South Jersey Avenue, was first constructed as the Nunns and Clark Piano Factory in 1861. In 1876, the Long Island Rubber Company purchased the property and began manufacturing second-rate rubber shoes and boots. The company changed names several times and constructed additional buildings in East Setauket. This building was destroyed by fire in 1904. The site of this factory, which employed many Eastern European immigrants, is occupied by a variety of businesses today.

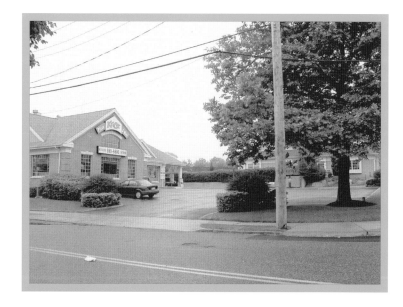

AROUND THE OLDEST VILLAGE IN BROOKHAVEN

Robert Nunns of the Nunns and Clark Piano Factory built this home around 1845. In 1874, it was owned by the Ridgway family. The house in this c. 1935 photograph stood between the present Setauket School and the Emma S. Clark Memorial Library. The property was purchased by the Three Village School District for the construction of the Setauket School, and the house was razed in 1954. (Courtesy of John McConnell.)

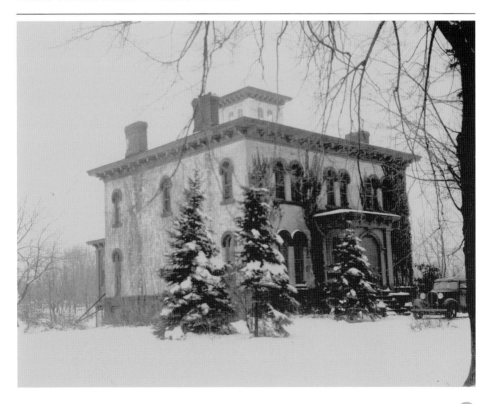

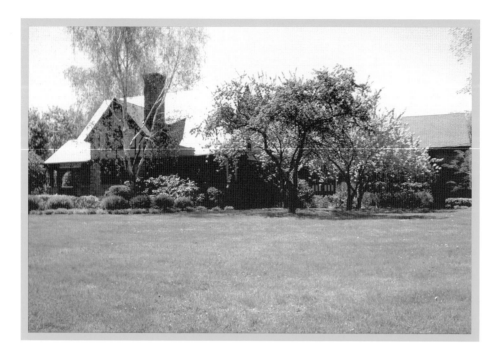

In 1892, the Emma S. Clark Memorial Library opened to patrons. It was financed by Thomas Hodgkins, who built it as a memorial to his niece. The small house to the right was home to a number of tenants, including the librarian, but was destroyed by fire in 1945. Emma S. Clark Memorial Library is Suffolk County's oldest continuous service library at its original location. The original library, shown in 1909, is at the heart of the present building.

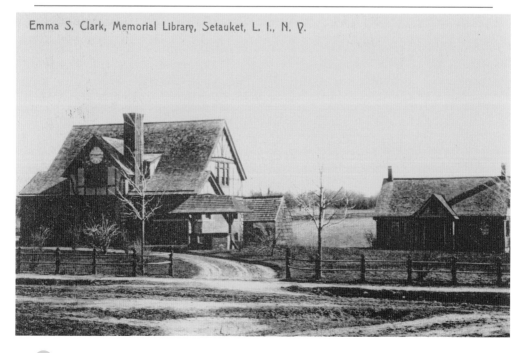

Emma S. Clark, Memorial Library, Setauket, L. I., N. Y.

AROUND THE OLDEST VILLAGE IN BROOKHAVEN

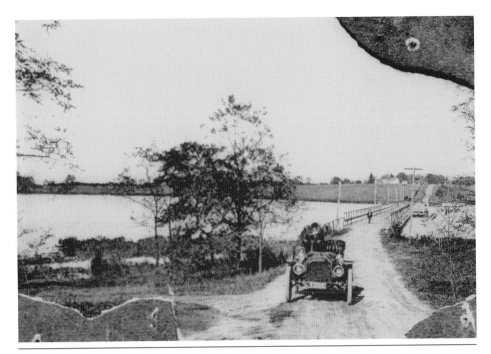

This bridge across Little Bay was built by the Strong family in 1879 to provide easier access to their homestead on Strong's Neck. It also provided a dock for schooners to unload coal. The bridge, damaged in the 1938 hurricane, was taken down after the hurricane of 1944. During Prohibition, the bridge was a convenient off-loading point for local rumrunners. Today access to the many homes built on Strong's Neck is only by Dyke Road.

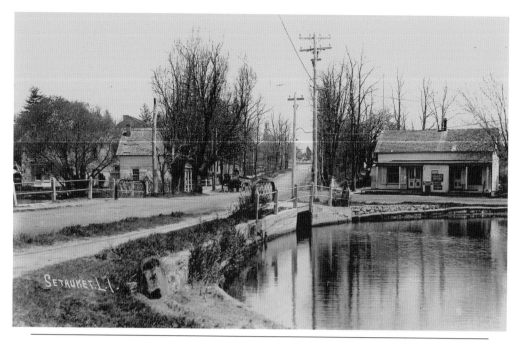

The Tyler Bothers' general store (right) and the post office (left) occupy the intersection of Main Street and Old Field Road in this 1915 photograph. This post office, also known as the "shack," sat in the present driveway to Frank Melville Memorial Park. The general store was moved in 1930 to 150 Main Street to become the American Legion hall. The bridge and roadway were rebuilt as part of the Frank Melville Memorial Park project. The park was dedicated in 1937.

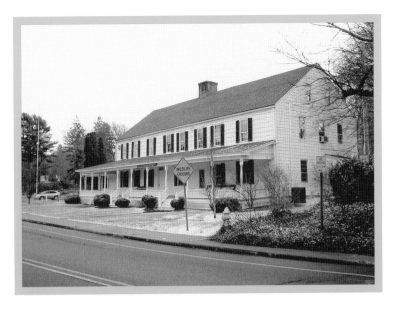

The Lake House, as it was known in 1910, was run by B. S. Tyler and advertised "Good Boating, Bathing, and Fishing, Automobile Parties Accommodated." Today, located in the historic district, the Setauket Neighborhood House serves the community as a meeting place, having been established as such in 1918 by Old Field businessman Eversley Childs.

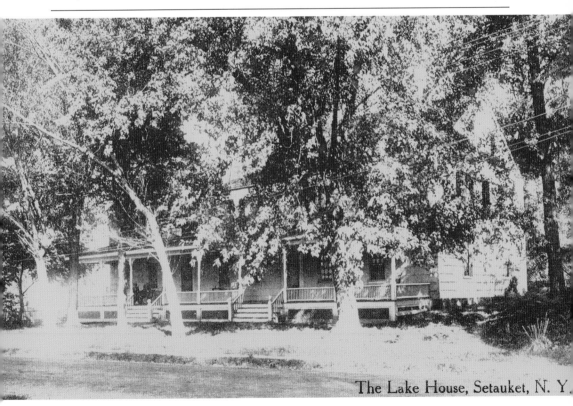

The Lake House, Setauket, N. Y.

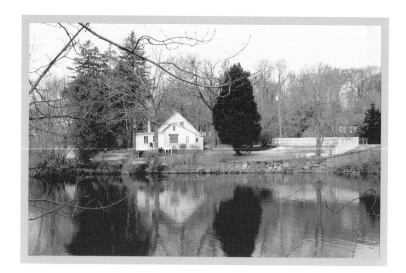

Ralph Hawkins built this house on the west shore of the millpond around 1780. The last addition was the kitchen wing in 1914. Israel (Izzy) Hawkins's wife, Ida, is said to be rowing the boat, around 1910. The Satterly-Jergenson House, built in the late 1600s, is just visible on the right. The house had remained in the Satterly family until the death of Mary Jergenson in 1966. One of the oldest houses in Setauket, it was purchased and remodeled by Ward Melville in 1967.

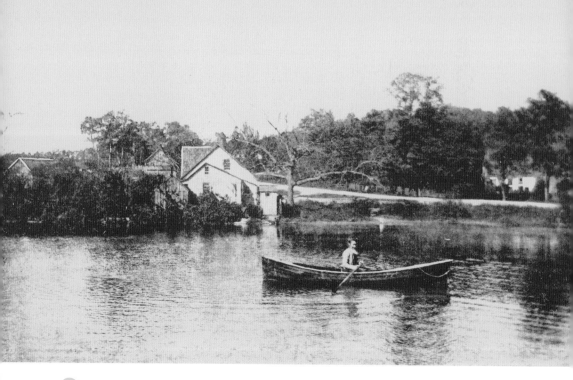

SETAUKET, L. I. Setauket Lake

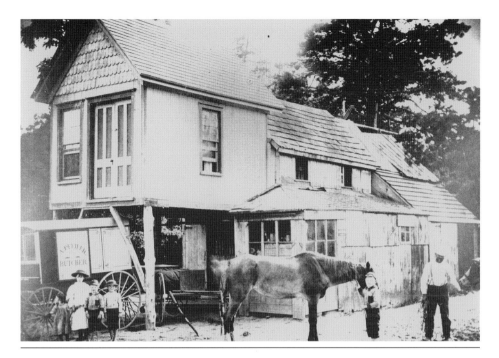

Standing in front of the family butcher shop in 1898 at Pfeiffer's Corner are, from left to right, unidentified, Sadie McCarthy, Reed Benedict Pfeiffer, Fannie or Eva Pfeiffer, William Pfeiffer, and unidentified.

This architectural wonder did not survive the 1950s. The current owner has created a parklike setting in stark contrast to the busy days of the past (see page 39).

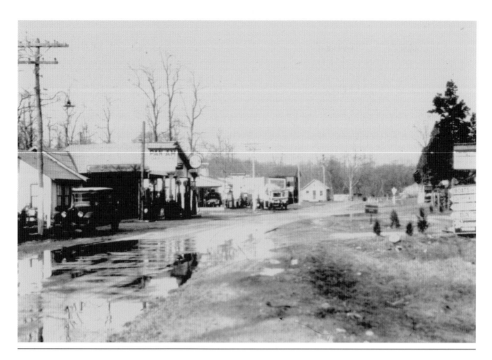

A busy commercial district existed along the old route of 25A. The utility pole (left) in this *c.* 1930 photograph was approximately at the corner of North Country Road and Thompson Hay Path. A 1926 Hudson is parked at the Pan-Am gasoline station. The building that became Joe Gumbus service station, Thy Oriental Food Store, and Great Escapes is next. Adolph Pfeiffer's store complex extends to the corner of Ridgway. The service station (right) renting boats and selling bait is the present site of the Three Village Historical Society.

Around the Oldest Village in Brookhaven

The Nassakeag School, shown in this early-20th-century photograph, stood approximately opposite Pond Path and the entrance to St. George Golf and Country Club on Sheep Pasture Road. Built in 1877, this one-room schoolhouse served the south Setauket community. In 1956, it was acquired by the Suffolk Museum and moved to their grounds. A new Nassakeag School opened on Pond Path in 1968. Today a modern home is located on the site. (Courtesy of Marilyn Wishart Varga.)

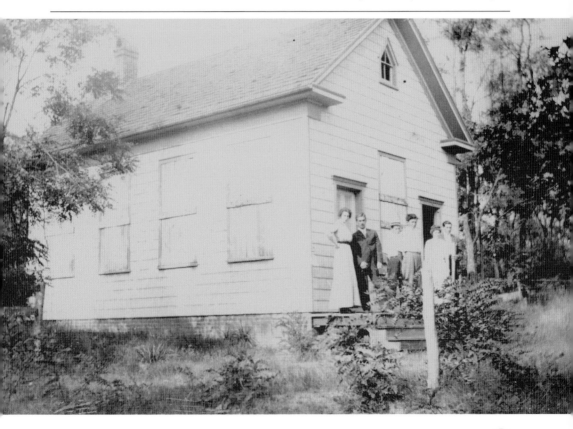

Merritt Hawkins built this house at 512 Pond Path in 1802 for his son Merritt Jr. to replace the previous home, which burned. It passed to his granddaughter Hester Ann, who married Ethelbert Selleck, and the house remained in the Selleck family through the remainder of the 20th century. Both the Hawkins and Selleck families were extensive landholders and farmed large areas of Nassakeag (South Setauket). The property is being preserved by the Town of Brookhaven. (Courtesy of Bee and Sue Jayne.)

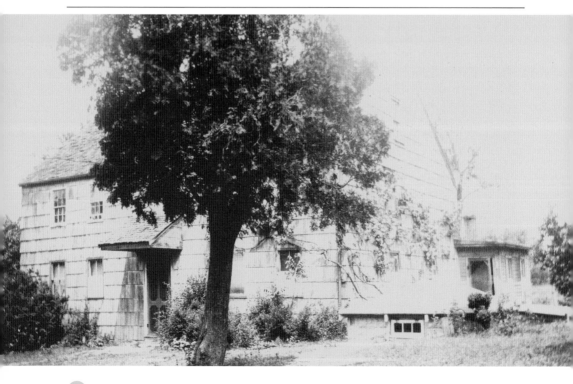

AROUND THE OLDEST VILLAGE IN BROOKHAVEN

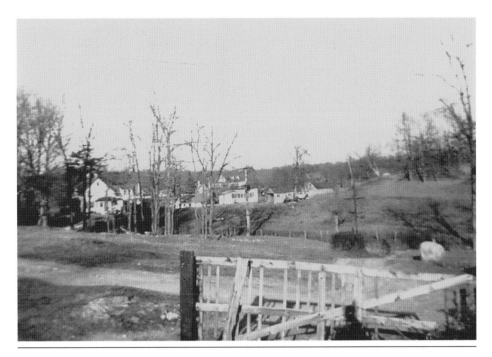

At Nassakeag (South Setauket) in the 19th century, Pond Path and Campus Drive, now populated with housing developments, was an extensive area of apple orchard with cider presses. In the early 20th century, the independent dairies of Chester Hawkins and Clifford Lewis merged to form Hawkins and Lewis Dairy. Milk, supplied by 12 cows, was sold into the mid-1940s. Pond Path is in the gully between the hills. Up to the recent past, the area to the west of Pond Path was the haunt of several well-practiced and very active local moonshiners.

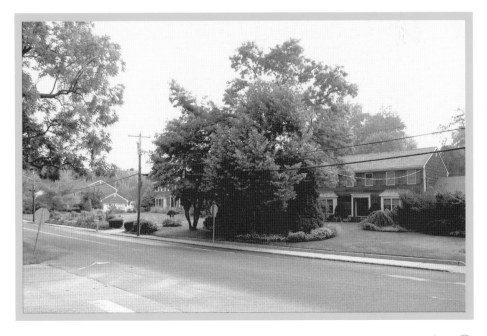

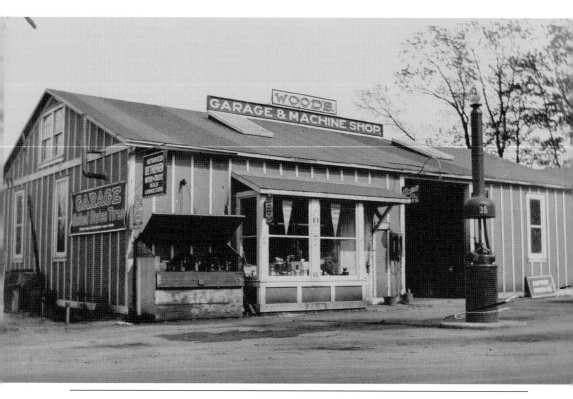

The corner of Route 25A and Sheep Pasture Road earned the name Wood's Corner because of Chester Wood's garage. The now-removed Sheep Pasture Road railroad underpass was behind the machine shop. The cold beer that Wood kept in the refrigerator made the customers' wait for repairs much more tolerable. After the garage closed, the space became the Corner Book Store. It is now a veterinary office. (Courtesy of James McNamara.)

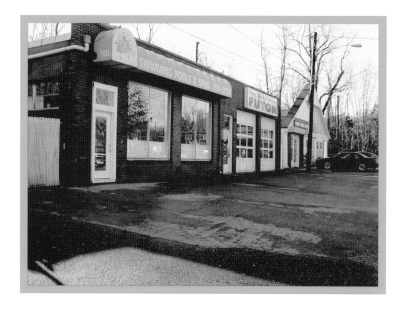

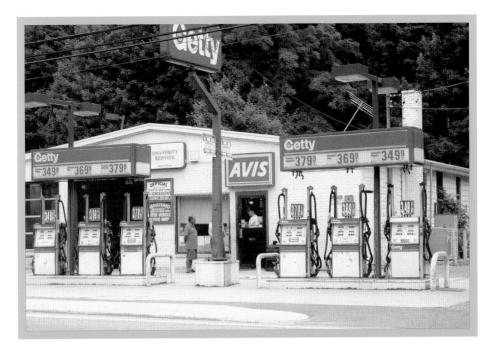

The attendant at I. J. Smith's Stony Brook Garage checked the oil, wiped the windshield, and dispensed Richfield gasoline at about 20¢ a gallon. The garage is on Route 25A opposite the Stony Brook Railroad Station. The second-floor residential quarters in this c. 1940 photograph were removed after the town passed an ordinance prohibiting living quarters above service stations. (Courtesy of Bee and Sue Jayne.)

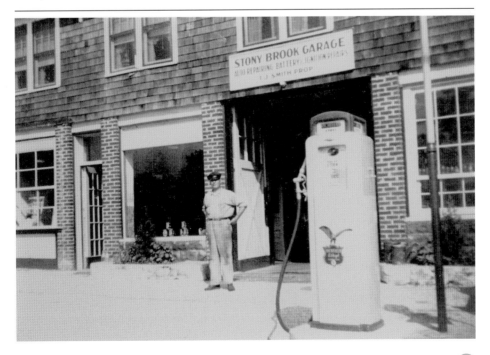

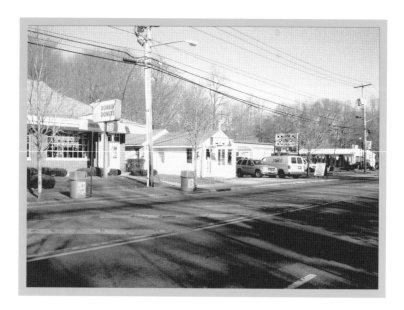

The tiny building shown here around 1935 was the Ashley B. Hammond Real Estate and Insurance agency. He specialized in waterfront lots that were "good buys." About 1940, Thelma Diebel operated her real estate office here. In the intervening years, a wide variety of businesses occupied the location. The building is now a dog-grooming salon. Surrounding businesses grew to serve commuters and the Stony Brook University population.

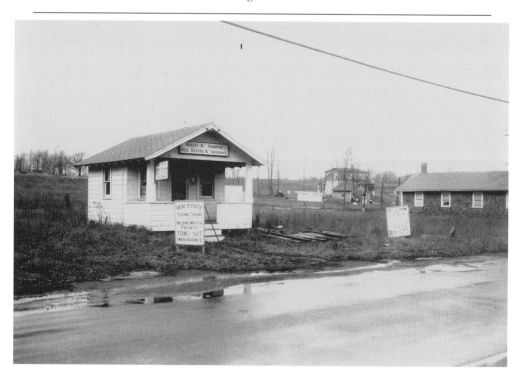

STONY BROOK TO OLD FIELD POINT

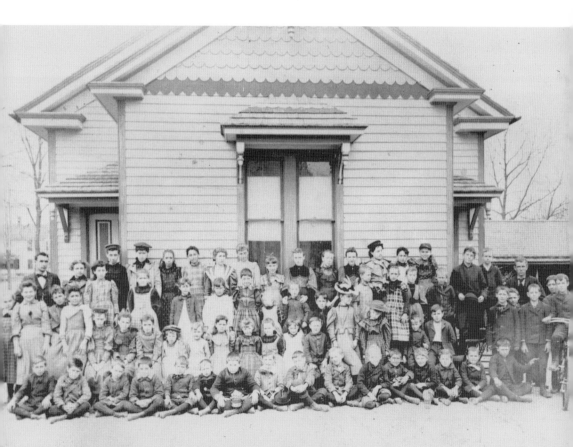

The students of the second Lower Stony Brook School were assembled for an official picture around 1895. This school, on the corner of Terrell Lane opposite the Stony Brook Community Church, is now a private residence. In 1900, Capt. Clarence Rayner purchased the building and used it for a sail loft. It also served as a village dance hall. The original blackboards were revealed in 1956 when the wallpaper was stripped. (Courtesy of Bee and Susan Jayne.)

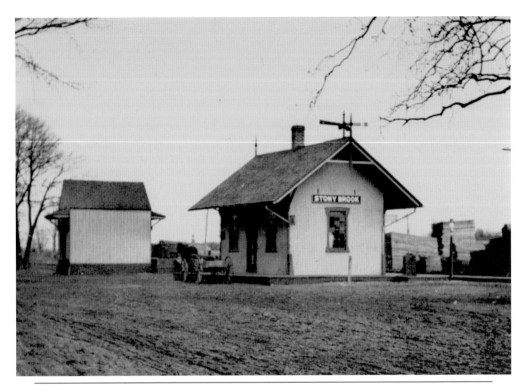

When the Port Jefferson line was opened in 1873, Albert Wells became the first station agent for Stony Brook. The station was built in 1888 and serves as the center of the present station. Freight was received at the small building to the left in this early-20th-century photograph. The lumber, in the background, is awaiting delivery to Bayles' Lumberyard in Stony Brook. Today this station serves commuters for the city and the university. In recent years the stationmaster was replaced with a vending machine.

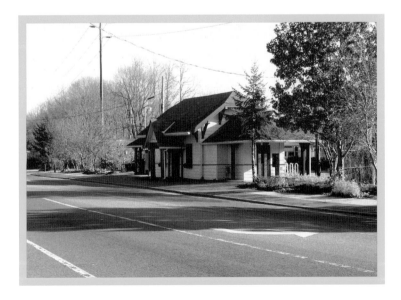

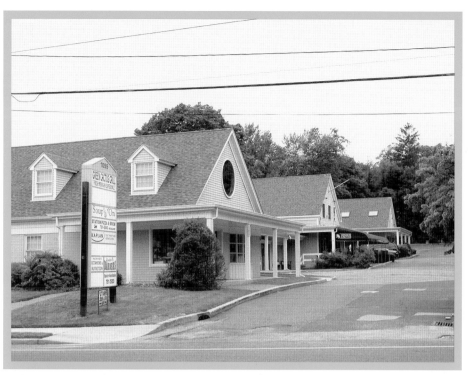

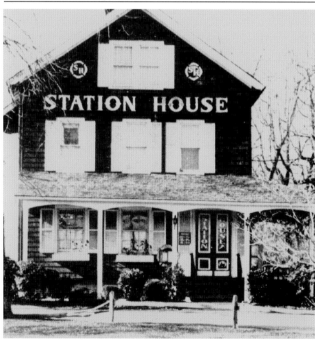

A popular spot on Route 25A was the Station House, an old-fashioned ice-cream parlor. Opened by Dr. Richard Rugen on May 1, 1959, it was sold in 1969 and closed in the early 1970s. The ice-cream parlor had a firehouse theme: the Fire-Boat, a really big soda (75¢); the Fire Bucket, takes five to seven to empty this bucket, ($5); and a Pineapple Phosphate (15¢). The vacant building burned in 1976 and was replaced by a strip of small stores.

THE THREE VILLAGES

The Stony Brook Hotel, Route 25A, evolved around the c. 1795 John Smith House. In the mid-19th century, it became a major boardinghouse for "summer people" and looked much as it does in the 1915 photograph. Welz and Zerweck Export Beer was featured in its saloon and bowling alley (right). In 1948, after being abandoned, the site was purchased by the Suffolk Museum. In 1951, its new carriage museum opened. Today this is the Long Island Museum of American Art, History, and Carriages.

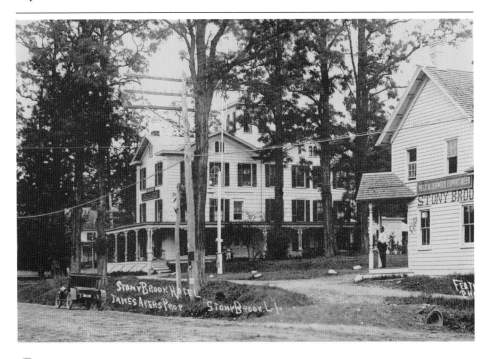

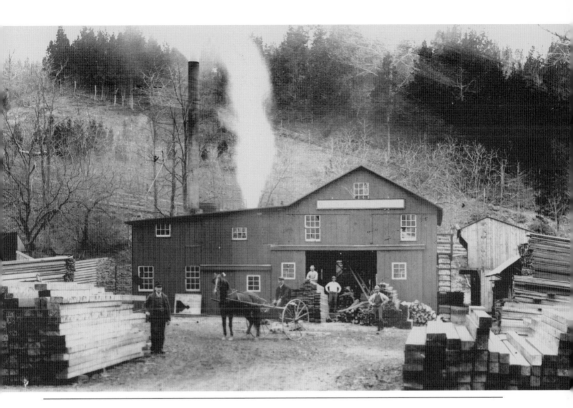

The second location of the D. T. Bayles and Son Lumberyard is shown here around 1910. The original yard was next to the Hawkins-Bayles House (see page 64). After several fires, the yard was moved to this location. It too burned in 1917 and was rebuilt. In 1973, the Museums at Stony Brook acquired this property across the street from its main complex. It adapted the main yard structures to storage for its collections, a history museum, and a gift shop that opened in 1979.

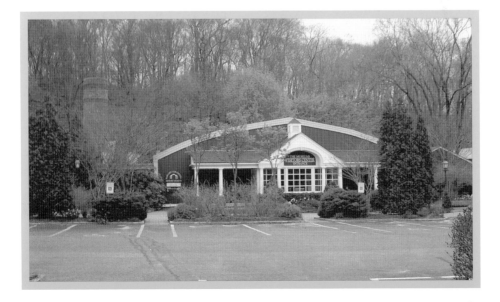

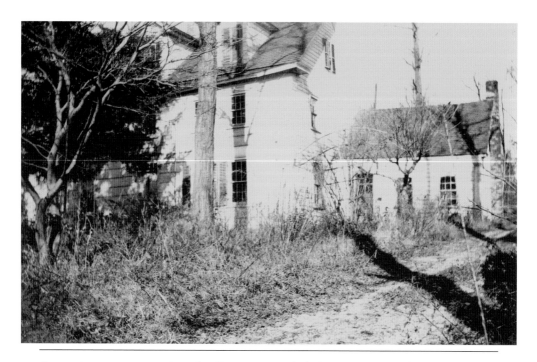

A popular restaurant today, the Country House is located at Main Street and Route 25A. The original building dates from around 1710 with a two-story addition by Obediah Davis around 1750. In 1838, it was purchased by English American actor Thomas Hadaway. His popular parties included séances attended by William Sidney Mount. The ghost of Annette Williamson, reputed to have been a spy hung by the British during the American Revolution, is said to inhabit the building. (Courtesy of Beatrice Jayne.)

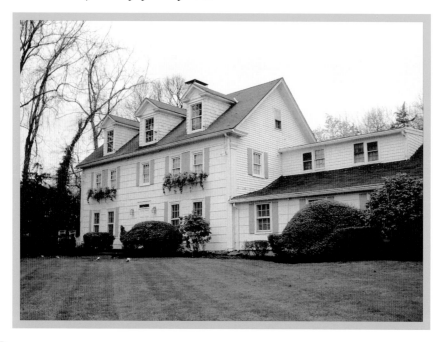

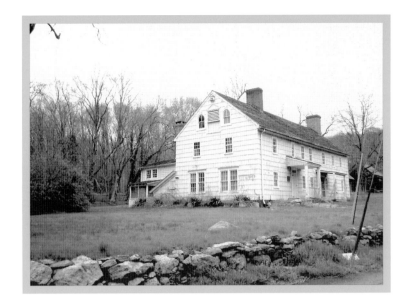

The Hawkins-Mount House sits at the busy intersection of Stony Brook Road and Route 25A. Built by Maj. Eleazer Hawkins around 1757, it was given to his son Jonas Hawkins who ran a store and ordinary here. Jonas's grandson was William Sidney Mount, one of America's foremost genre painters. The older picture shows the home round 1915. It was restored in 1945, with the removal of the 1858 dormers and other details, to reflect the way it looked in Mount's 1845 painting of the home.

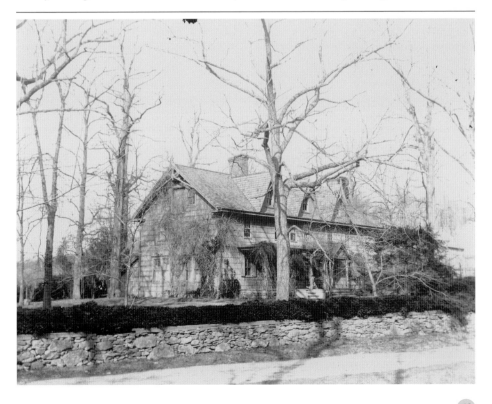

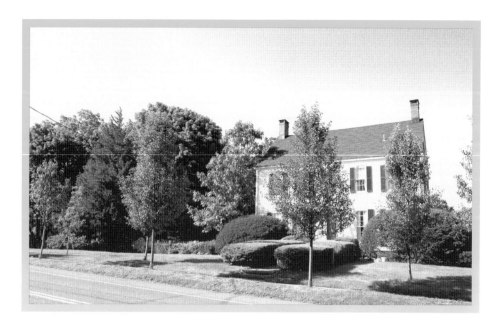

The Hawkins-Bayles House is shown here about 1880 in Victorian garb. It was built around 1810 as a Georgian Colonial by Joseph Smith Hawkins Sr. After Joseph's death, Nathaniel S. Hawkins acquired the house in a swap with his brother. In 1872, David T. Bayles, son-in-law of Nathaniel, remodeled the original Georgian house to the Victorian style of the day. Ward Melville acquired the house and in 1946 returned it to its Georgian appearance. The D. T. Bayles lumberyard complex is to the left.

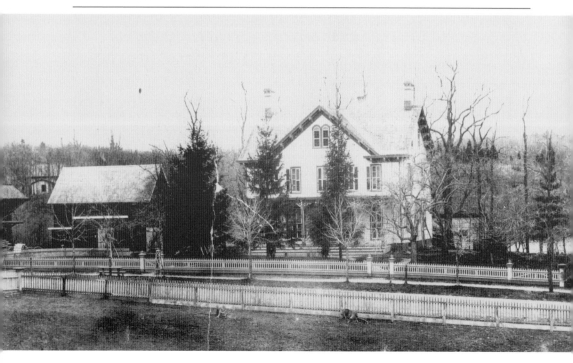

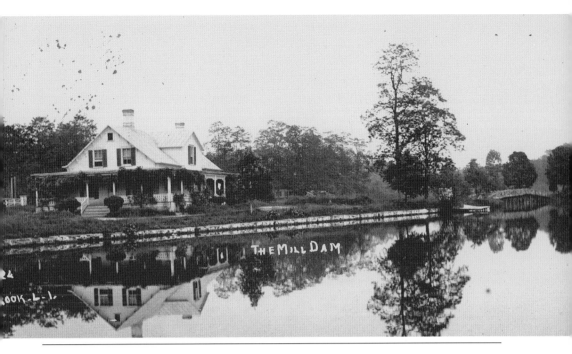

THE MILL DAM

OOK-L-I.

In the c. 1900 photograph, the Kane House, built around 1790, stands in what is now T. Bayles Minuse Park. Edward Kane, a Brooklyn brewer, purchased the house around 1885 and became a large local landowner. His business interests in Stony Brook centered on the beverage industry, including making cider for export and operating a wholesale liquor store and a saloon. As owner of the millpond, he cut and sold ice.

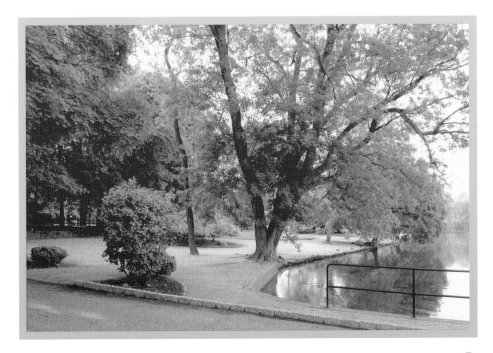

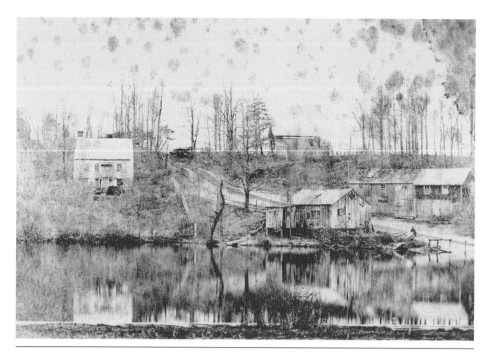

On the west side of the Stony Brook millpond Nathaniel and Catherine Ketcham built a house around 1800. They were followed by blacksmiths Elkanah Hawkins (1813) and Charles Jayne (around 1840). The blacksmith shop stands on the edge of the millpond in the c. 1895 photograph, and the wheelwright shop is across Harbor Road. In 1997, the Paul Simons Foundation acquired the house and 83 acres on Harbor Road and established Avalon Park and Preserve.

STONY BROOK TO OLD FIELD POINT

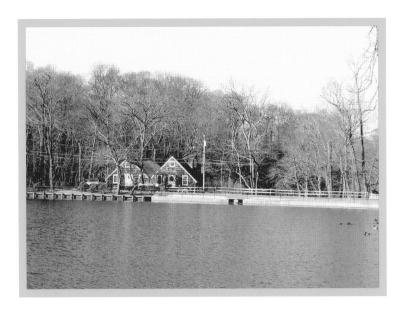

In 1699, the original gristmill and milldam at Stony Brook were built. Silting of the pond reduced the flow of water, necessitating the removal of the mill to the north. When this photograph was taken around 1908, Harbor Road in front of the mill was a major east-west route. This mill, as with most others, was adapted to saw lumber when there was a demand.

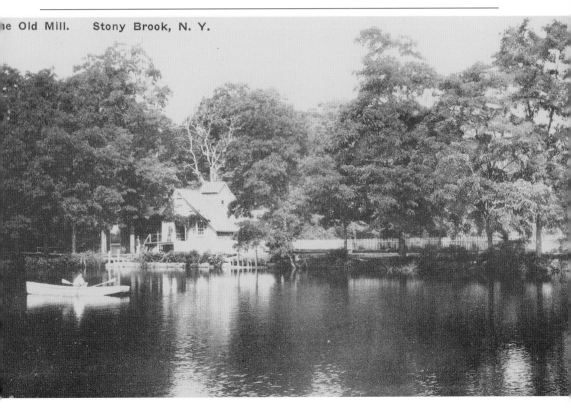

Old Mill. Stony Brook, N. Y.

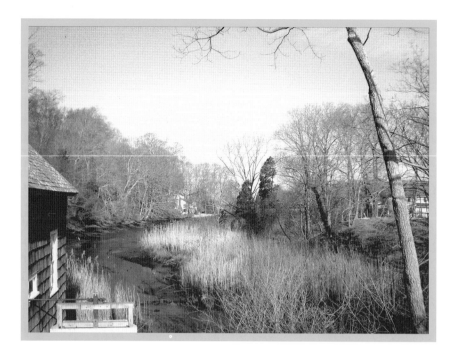

Stony Brook Creek looking north from the milldam shows the creek at low tide around 1910. As early as 1838, the creek was a trickle at low tide and only accessible at high tide. In the first half of the 19th century, William Smith Wells built several coasting ships on what is now the North Fork Bank property. In 1939 and 1940, Ward Melville extensively modified the shores of the creek during his construction of the new Stony Brook Village.

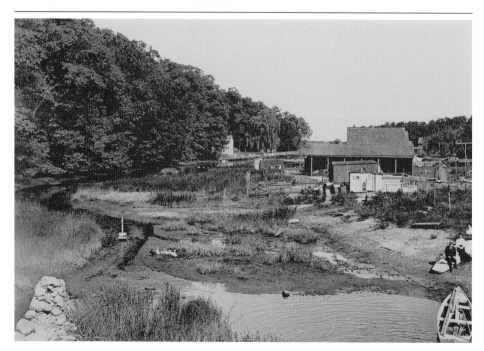

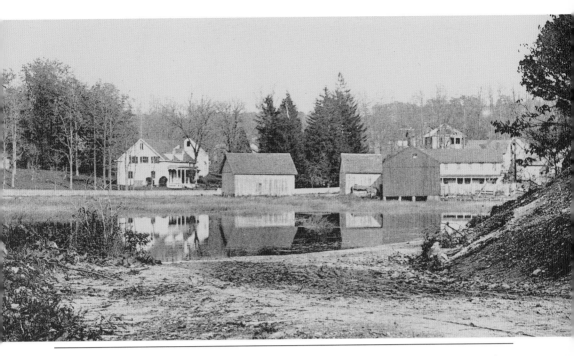

In this view of Stony Brook Village from across the creek at Emmett's Point around 1900, the only remaining building is the Jonas Smith house, now the Three Village Inn. The barn complex on the creek belonged to Capt. Furman Horton. These buildings were either razed or moved when the new Stony Brook Village center was built in 1941. The Sid Davis house to the right of the barns was made into two small homes that are now next to the old Garden Club Exchange (see page 89).

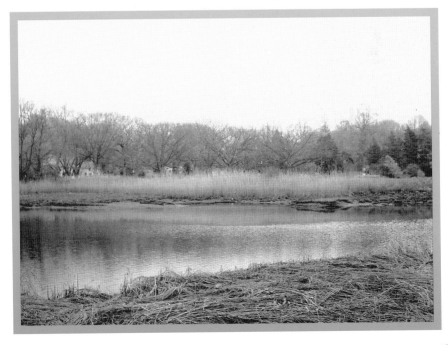

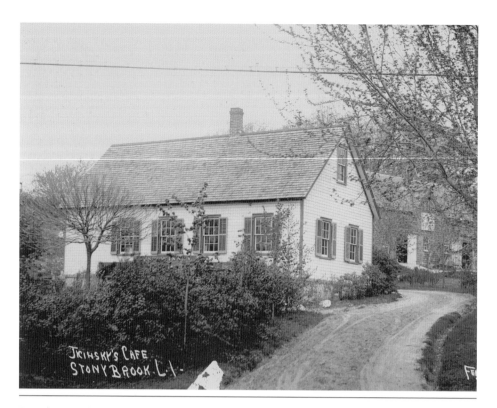

Joseph Jicinisky converted an existing barn into this tavern in 1905. It operated as a saloon until Prohibition, when it became a gaming parlor and shut down completely by the late 1920s. In this *c.* 1915 postcard, the tavern entrance is at the rear to allow patrons to enter without scrutiny from the churches up the street. At the time it was the only local gathering place for the village men. It was converted into a private residence in 1974.

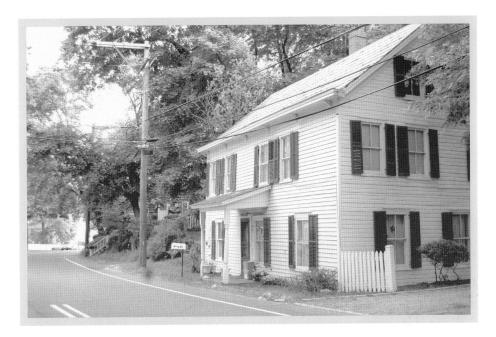

Locals referred to this bakery as "Capt. Jack's Place." Pictured here around 1900, it operated until 1920 and is now a private home. Capt. Jack Youngs sold pies and cakes from three wagons that made daily rounds. Bread was 6¢ a loaf and 12 little cupcakes 10¢. In 1904, Joseph Jicinisky wanted to purchase the property from Lucy Darling. She refused to sell since his plans included a tavern. In 1905, Walter B. Sherry bought the property from Darling and immediately resold it to Jicinisky.

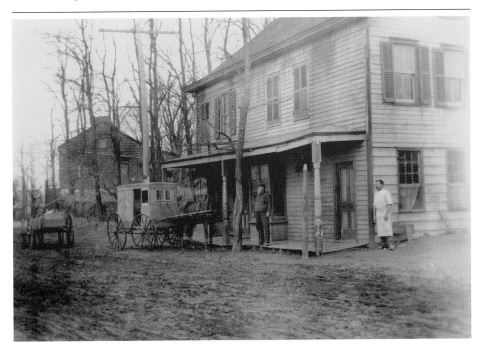

Harbor Road and Main Street, due to its proximity to the Stony Brook Grist Mill, was the center of many businesses. In this *c.* 1920 photograph, Dahlbergs Drug Store and Soda Fountain occupies the site. Over the years, the corner was home to a feed and grain store, a tearoom, the fire station, a fruit store, and a boys' club. It is currently the location of a private home built in 1941. (Courtesy of Frank Newman.)

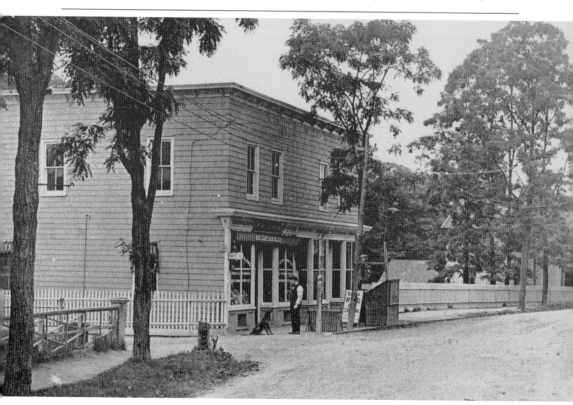

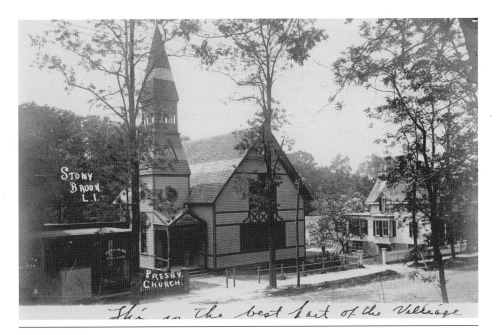

The 1866 Presbyterian church on Main Street was torn down in 1954 due to the lack of a congregation. The 1910 postcard shows Peterman's store to the left of the church. Today two homes occupy these sites opposite All Souls Church. The home in the center of the contemporary photograph is a converted barn that was moved up from the creek in 1972 after being flooded many times. The home on the far right of each photograph is the Stoessel home, dating from the early 1800s.

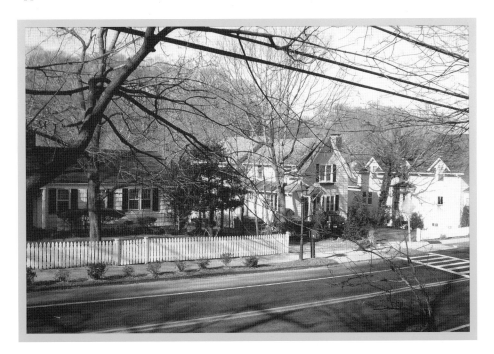

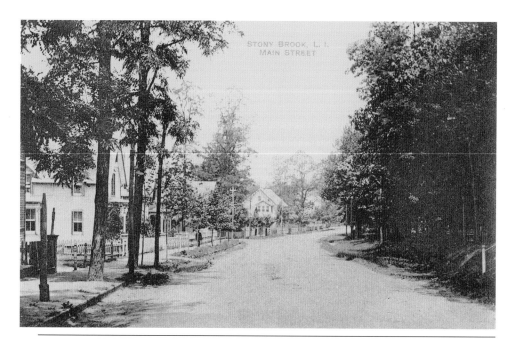

In the *c.* 1910 photograph, taken in front of the Presbyterian Church, the Stoessel House is at the left, followed by the *c.* 1860 B. F. Wells House. Beyond Wells is the home of Orlando G. Smith, who operated a butcher shop from 1898 until 1911. In 1922, the butcher shop was moved back from the road and remodeled into a home. The cluster of trees at the center is the present location of the North Fork Bank with the Sherry-Squire House beyond.

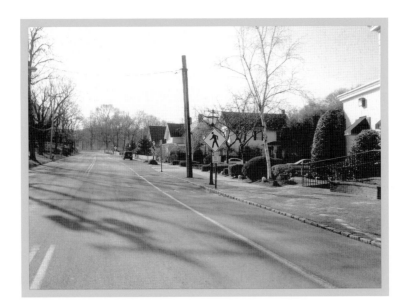

Looking south along Main Street from just north of the bank, the first small building at the right in the c. 1895 photograph is Gould's Store. The Sherry-Squire House is next, followed by Orlando G. Smith's, the Wells-Powell house, and the Stoessel House, on the curve of the road. The Presbyterian church with its steeple is visible at the center. The rutted nature of Main Street is a product of wagon traffic and freezing and thawing during the winter.

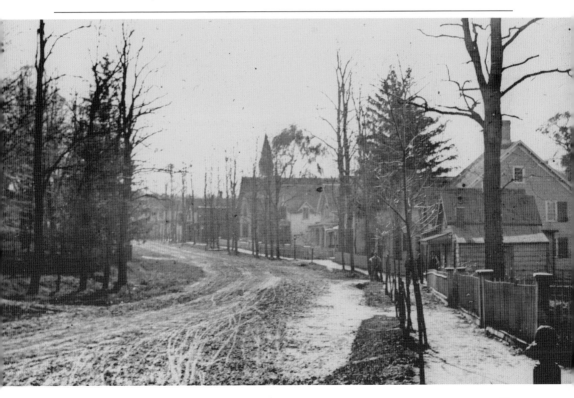

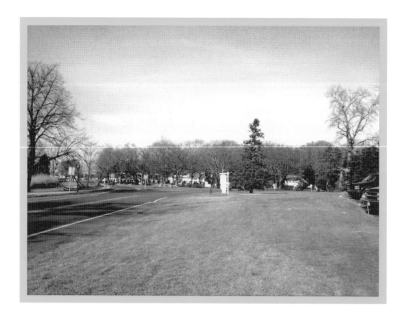

The *c.* 1822 Old Brick House, in the center of this 1895 photograph, is a private residence. In 1907, the building was remodeled, a third floor was added to serve as a meeting hall for the Odd Fellows, and retail space was on the ground floor. Over time, the building was home to many businesses, including the Stony Brook Library and the Bank of Suffolk County. All the buildings in this photograph were demolished during the redevelopment of Stony Brook in 1940. In today's landscape, the Old Brick House would be on the village green. (Courtesy of Ed Meachum.)

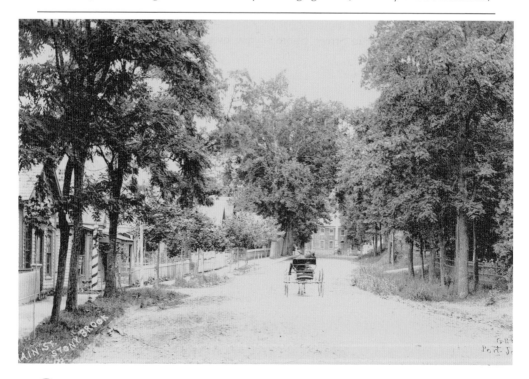

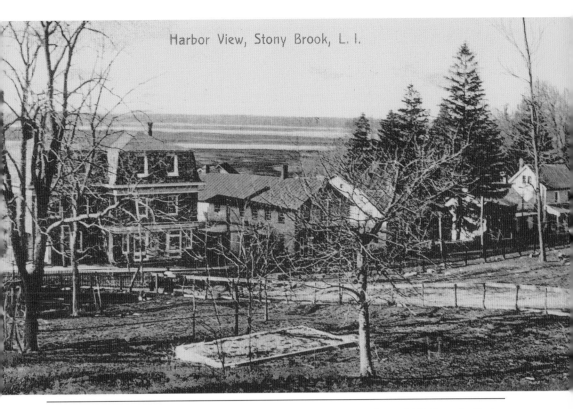

Harbor View, Stony Brook, L. I.

Before 1941 individual family-owned businesses lined the west side of Main Street and occupied the triangle formed by the intersection of Main Street, Shore Road, and Christian Avenue. This view overlooking the Stony Brook Harbor shows the east side of this triangle. From left to right are the Odd Fellows hall, the *c.* 1770 Stone Jug (Suffolk Museum), the Mills house, and other homes. The current view overlooks the Stony Brook village center, constructed in 1941 to replace the original business districts.

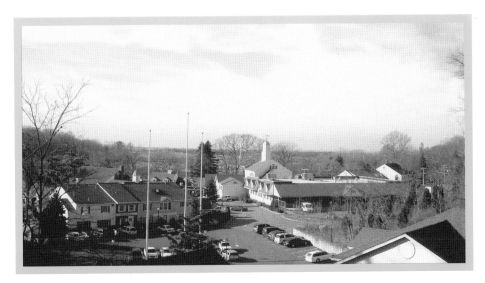

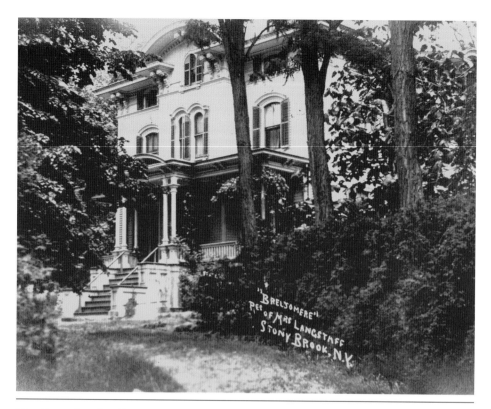

The Stony Brook village center sits on the site of Breljomere. This home, as well as the home on the facing page, was built by Jonas Smith's widow, Nancy, for two of her nieces. This home, built for Louisa Smith Pettit Norton, was purchased in 1902 by Dr. John Elliot Langstaff as a summer home for his family. It was demolished in 1939 to make way for construction of the 1941 village center designed with the post office as its focal point.

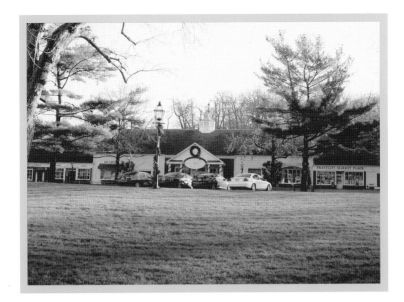

Built for Julia Smith Whitford in 1870, this impressive home was demolished in 1962 to make way for the south addition to the Stony Brook village center, which would house a supermarket. Before it was demolished in 1962, it served as additional lodging for the Three Village Inn and classrooms for the school district. The concept for the original 1941 village was to relocate the existing shopkeepers from the main street. Today the center houses designer boutiques and specialty shops, gone are the mom-and-pop stores of yesterday.

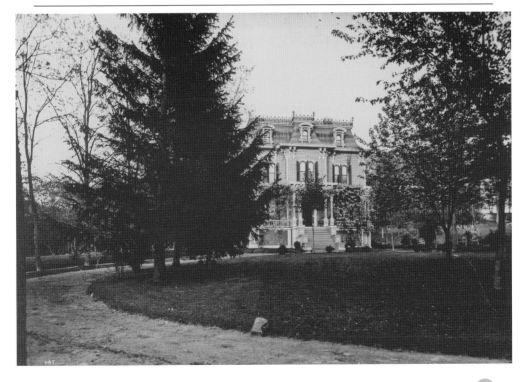

A late-19th-century Victorian addition hides the mid-18th-century farmhouse at the heart of Dickerson House shown around 1929. In 1946, Suffolk County, at the instigation of John Ward Melville, planned to move Main Street closer to the water. The Dickersons resisted, and a bitter public relations campaign ensued. The property was condemned, and the buildings demolished. The Hercules Pavilion stands in the backyard of the Dickerson House. The gas main to this house was finally turned off in 2003. (Courtesy of Bee and Susan Jayne.)

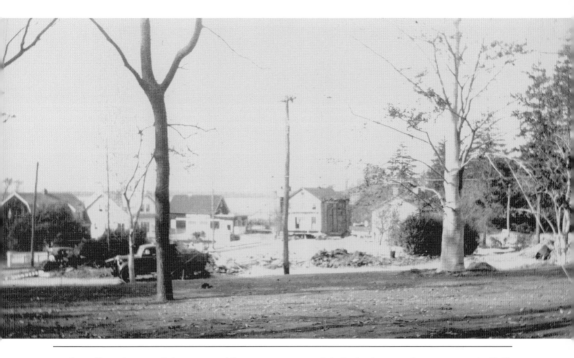

Today all evidence of the original business district is gone, now replaced by the village green. The Suffolk Museum (the Old Stone Jug) building at the center of this November 4, 1941, photograph, is in the process of being moved to Christian Avenue where it will be attached to the remodeled firehouse for a new Suffolk Museum, predecessor of the Museums at Stony Brook. After the museum moved to the site of the old Stony Brook Hotel, the Garden Club Exchange took over the building from 1979 to 2004. (Courtesy of Bee and Susan Jayne.)

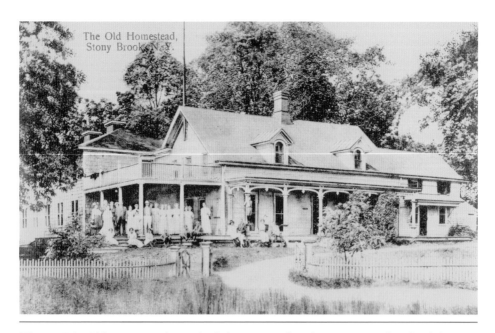

The Old Homestead,
Stony Brook, N.Y.

The *c.* 1751 Old Homestead was built by Richard Hallock. It was purchased in 1835 by Jonas Smith as a summer home. Smith became a major landholder in Stony Brook and the house remained in the family until 1907, when the Stony Brook Assembly acquired the building. After the assembly moved to the Stony Brook School for Boys in 1922, the building remained unoccupied until 1929, when Jennie Melville purchased it for the Three Village Tea Room and Garden Club Exchange. The building, much expanded, is now the center of the Three Village Inn.

Duane C. "Ducky" Cole operated the Community Service Station at the corner of Christian Avenue and the old triangle opposite the Three Village Inn. After the construction of the new Stony Brook village center, Cole operated the new service station on the south end of the shopping center. Ducky's wife, Peggy, ran the station during World War II while he was in the navy. The war memorial, dedicated in 1946, now occupies the site.

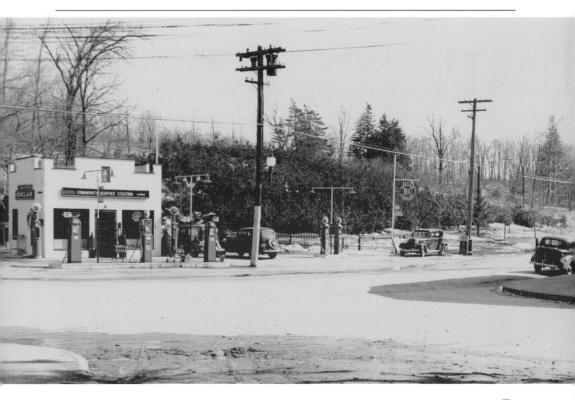

This *c.* 1935 photograph shows the Stony Brook Yacht Club building, which opened in 1930. The club, begun in 1913, met previously at the firehouse. Today the original building has been extensively expanded and modified.

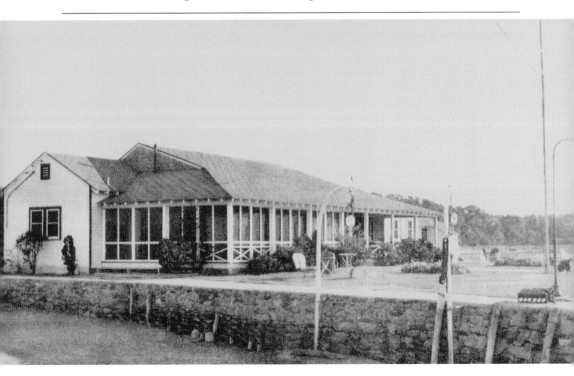

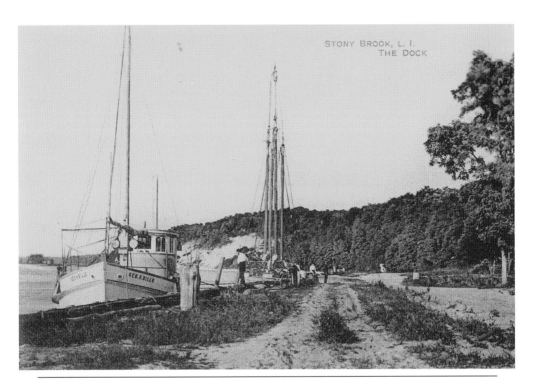

This *c.* 1910 photograph shows the *Geo. B. Mills,* an oyster dredge, and two sailing vessels tied up at the old Jonas Smith Dock. The sailing vessels were still engaged in the cordwood trade. In Stony Brook, in the early 20th century, there were two wharfs, four shipyards, and at least 24 vessels in the cordwood trade, carrying 4,000 cords of wood from the area. Today only pleasure craft may be found tied up at the new town dock.

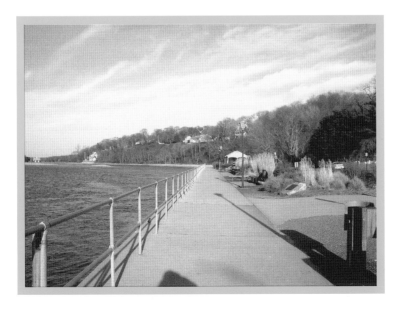

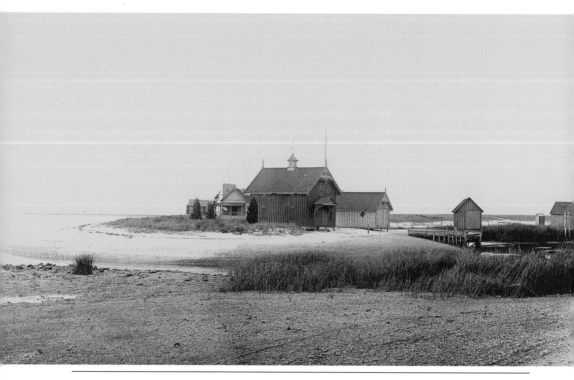

The Gamecock Cottage, shown around 1910, was already present at Shipman's Point when the property was purchased by William Shipman in 1870 and used as a boathouse. Shipman added gingerbread trim to reflect the style of his estate on Cedar Street. Jennie Melville converted the boathouse into the Gamecock Cottage and rented it out as part of the Three Village Inn; it is currently owned by the Town of Brookhaven. The boat house at the right, named the Barnacle because it seemed to cling to the shore, was destroyed by arson in May 1992.

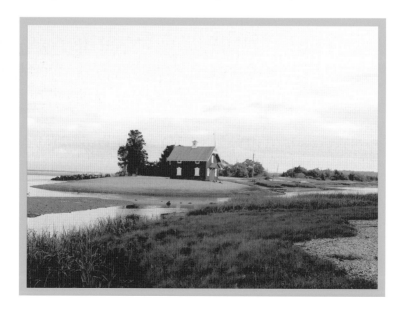

The West Meadow Beach cottages were the topic of heated debate for generations. The land was owned by the Town of Brookhaven and leased by the cottage owners, some since the 1920s, and the debate came to a head in 2004. The leases were not renewed, and the removal of the structures began in December of that year. (Courtesy of Susan B. Jayne.)

Christian Avenue today shows no evidence of the former business district. All the stores were owned and run by local families. In 1937, from left to right, are Fred Brush's Barbershop, the post office, the firehouse, Smith's Market, Henry Peterman and Harold Norton's Village Grocer, O. C. Lempfert Insurance, and Gould's Candy and Stationery Store. All were relocated in the new village, and the existing structures were modified, moved, or razed in 1941. (Courtesy of Bee and Susan Jayne.)

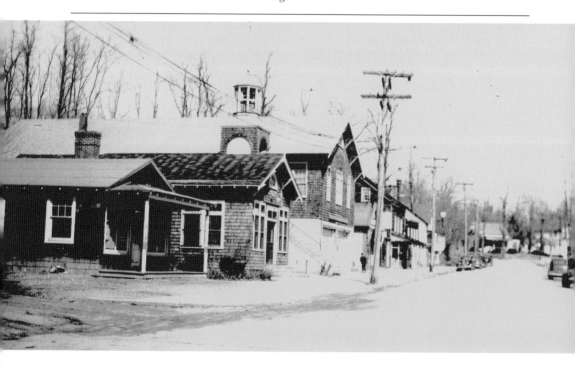

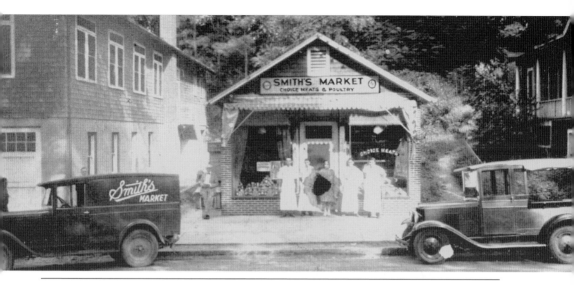

Percy W. Smith's Market, the only meat market in town, was located between the firehouse and the grocer on Christian Avenue. The pride of the market was its new delivery trucks, a 1929 Dodge (right) and the 1929 Reo (left). The building was razed in 1941 during the village construction. It would be replaced by the Sid Davis House, a two-family home from the old business triangle that was split into two separate residences, one of which is visible in the photograph below. (Courtesy of Marilyn Wishart Varga.)

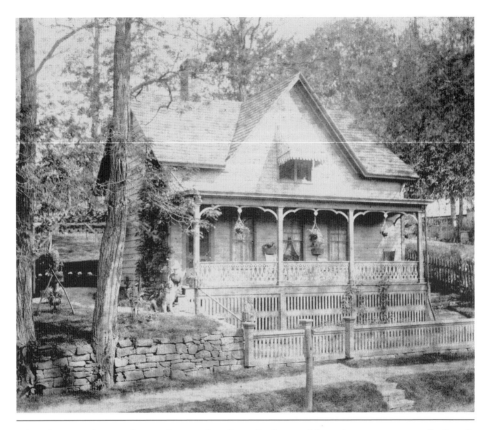

This home dating from the mid-19th century is located at 261 Christian Avenue. In 1858, the Richard Davis family owned the house. Note the intricate porch details in this 1890 photograph. The porch was removed in 1979.

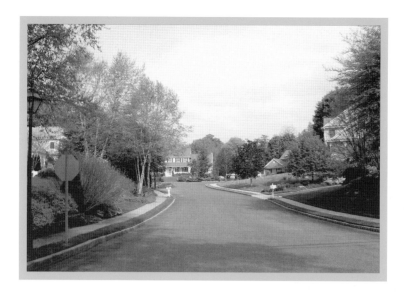

The Stony Brook Union Free School, overlooking Christian Avenue, was constructed in 1898 to serve Union Free School District No. 1. It combined the Lower Stony Brook School (see page 57) and the Upper Stony Brook School (28 Main Street). In 1951, this school was torn down with the completion of the Christian Avenue School on this site. The school district sold the Christian Avenue School. It was demolished in February 1994 when the roof collapsed. Today six Victorian-style houses occupy the school site and the cement steps are approximated by Heron Hill.

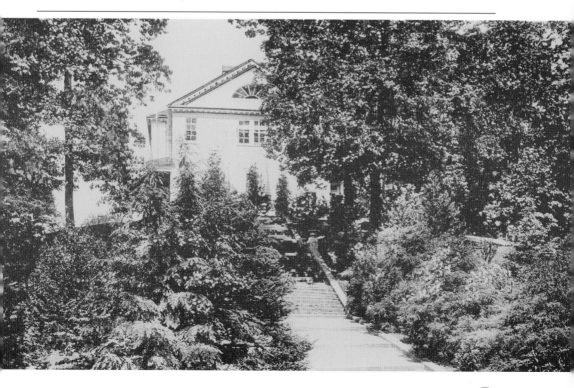

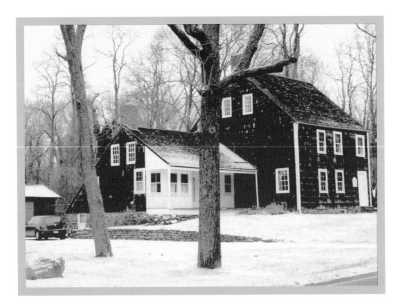

The Captain Eleazer Hawkins House, shown around 1900 at Cat Hollow, is by some considered to be the oldest house in Stony Brook. The small saltbox portion dates from 1660 and the addition to 1820. Captain Hawkins, it is said, came upon an abandoned ship containing a chest of money. After sharing the find with his crew he had enough left to purchase land for his children. One of the parcels of land is the site of the Hawkins-Mount House. (Courtesy of Bee and Susan Jayne.)

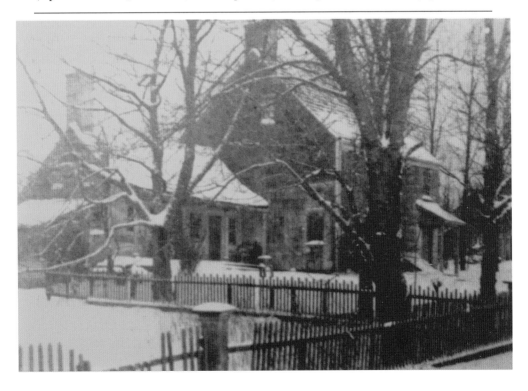

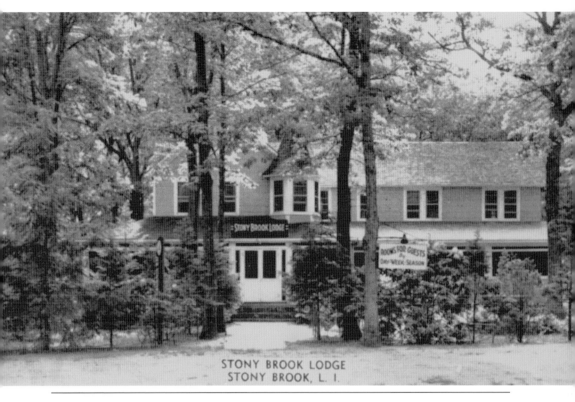

STONY BROOK LODGE
STONY BROOK, L. I.

The Gregsons ran a restaurant, bar, and rented rooms here from the 1920s into the 1940s. After the Gregsons, Andrew Lape, a local tavern owner, bought the premises for his wife, Anna, who managed it as restaurant, cocktail lounge, and summer rooming house. It was also reputed to have been a speakeasy during Prohibition. Located at the corner of Quaker Path and Lubber Street, today it is apartments.

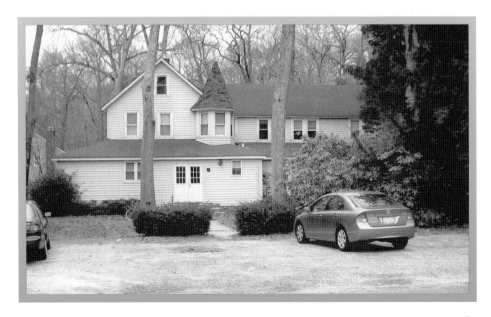

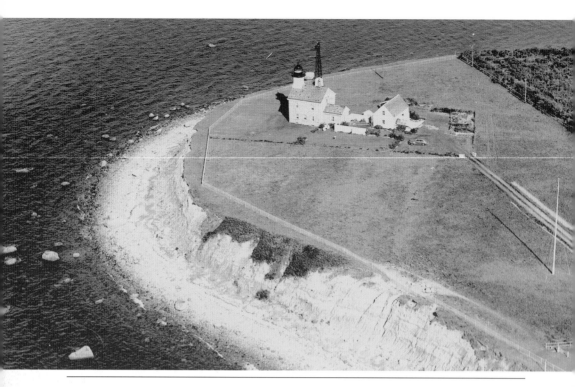

The present Old Field Lighthouse was built in 1868 to replace the original 1823 light. The 1824 keeper's house is at the right. Erosion has taken its toll on the bluff between the 1941 and 2007 photographs. The two jetties have reduced the effects of erosion. The bluff in 1941 (above) extended approximately halfway out the length of the two jetties. It was from the bluff in front of the lighthouse that Elizabeth Smith, lighthouse keeper, witnessed the burning of the steamship *Lexington* on January 13, 1840.

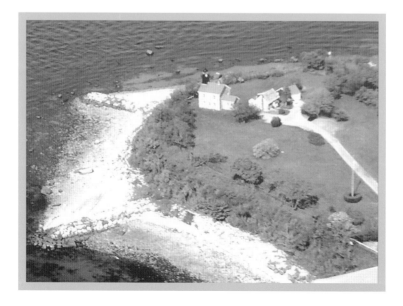

The Three Village Historical Society's history center at 95 North Country Road in Setauket satisfies many roles by providing staff and volunteers office and storage space, housing changing and permanent exhibitions, and sustaining a burgeoning gift and book shop filled with publications crafted to engage and educate history buffs of all ages and levels of interest. The building was moved to its present location in 1961 by the Society for the Preservation of Long Island Antiquities (SPLIA) and purchased by the Three Village Historical Society in 1998.

Across America, People are Discovering Something Wonderful. *Their Heritage.*

Arcadia Publishing is the leading local history publisher in the United States. With more than 3,000 titles in print and hundreds of new titles released every year, Arcadia has extensive specialized experience chronicling the history of communities and celebrating America's hidden stories, bringing to life the people, places, and events from the past. To discover the history of other communities across the nation, please visit:

www.arcadiapublishing.com

Customized search tools allow you to find regional history books about the town where you grew up, the cities where your friends and family live, the town where your parents met, or even that retirement spot you've been dreaming about.